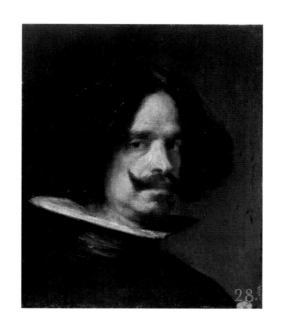

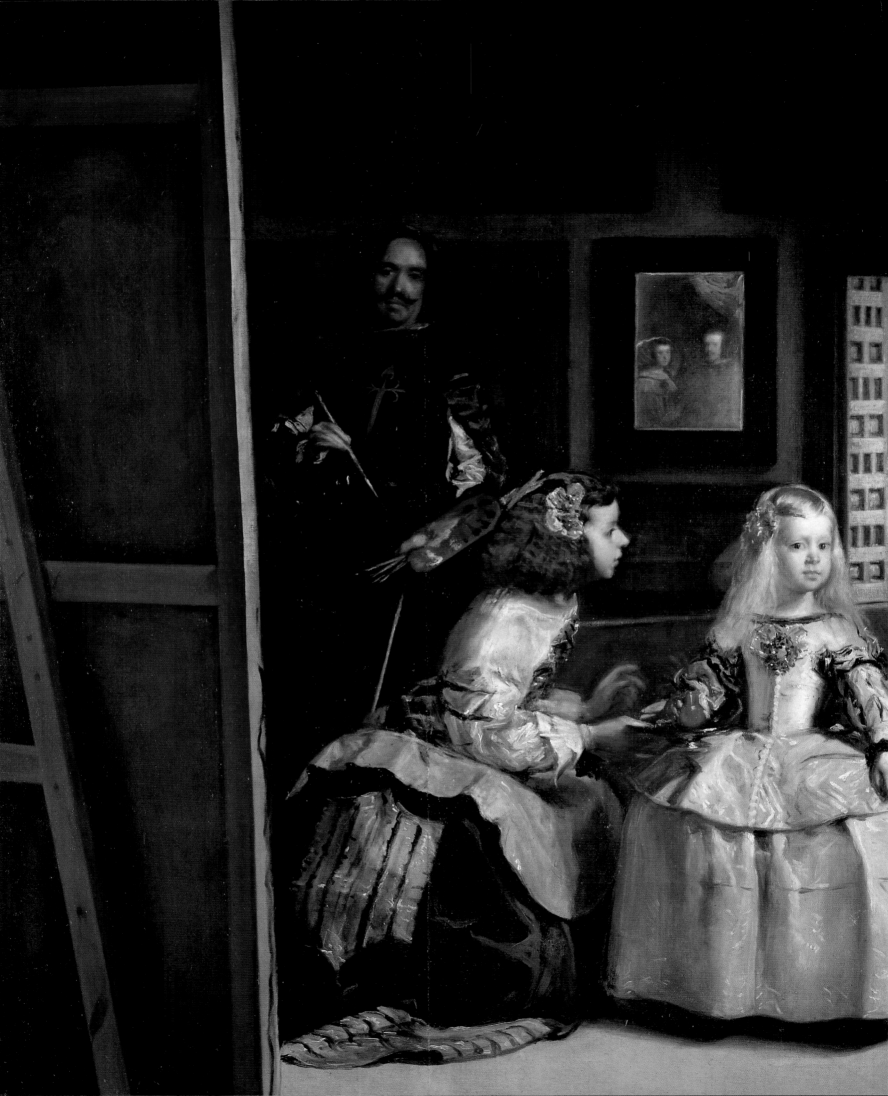

Norbert Wolf

DIEGO VELÁZQUEZ

1599–1660

The Face of Spain

TASCHEN

PAGE 1:
Self-Portrait, c. 1640
Oil on canvas, 45.8 x 38 cm
Valencia, Museo de Bellas Artes de San Pío V

PAGE 2 :
Las Meninas or *The Royal Family* (detail), 1656/57
Oil on canvas, 318 x 276 cm
Madrid, Museo del Prado

BELOW:
Infanta Margarita, c. 1656
Oil on canvas, 105 x 88 cm
Vienna, Kunsthistorisches Museum

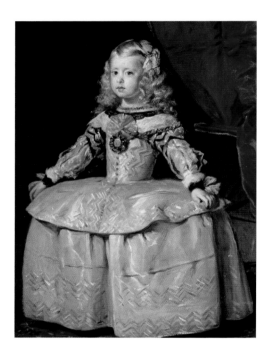

To stay informed about upcoming TASCHEN titles, please request our magazine at www.taschen.com/magazine
or write to TASCHEN America, 6671 Sunset Boulevard, Suite 1508, Los Angeles, CA 90028, USA;
contact-us@taschen.com; Fax: +1-323-463-4442. We will be happy to send you a free copy of our magazine,
which is filled with information about all of our books.

© 2011 TASCHEN GmbH
Hohenzollernring 53, D–50672 Köln
www.taschen.com
Original edition: © 1999 Benedikt Taschen Verlag GmbH
© 2011 VG Bild-Kunst, Bonn, for the reproductions of Dalí, Bacon and Picasso
Editor: Juliane Steinbrecher, Cologne
Production: Martina Ciborowius, Cologne
Cover design: Sense/Net Art Direction, Andy Disl and
Birgit Eichwede, Cologne, www.sense-net.net

Printed in China
ISBN 978–3–8365–3192–4

Contents

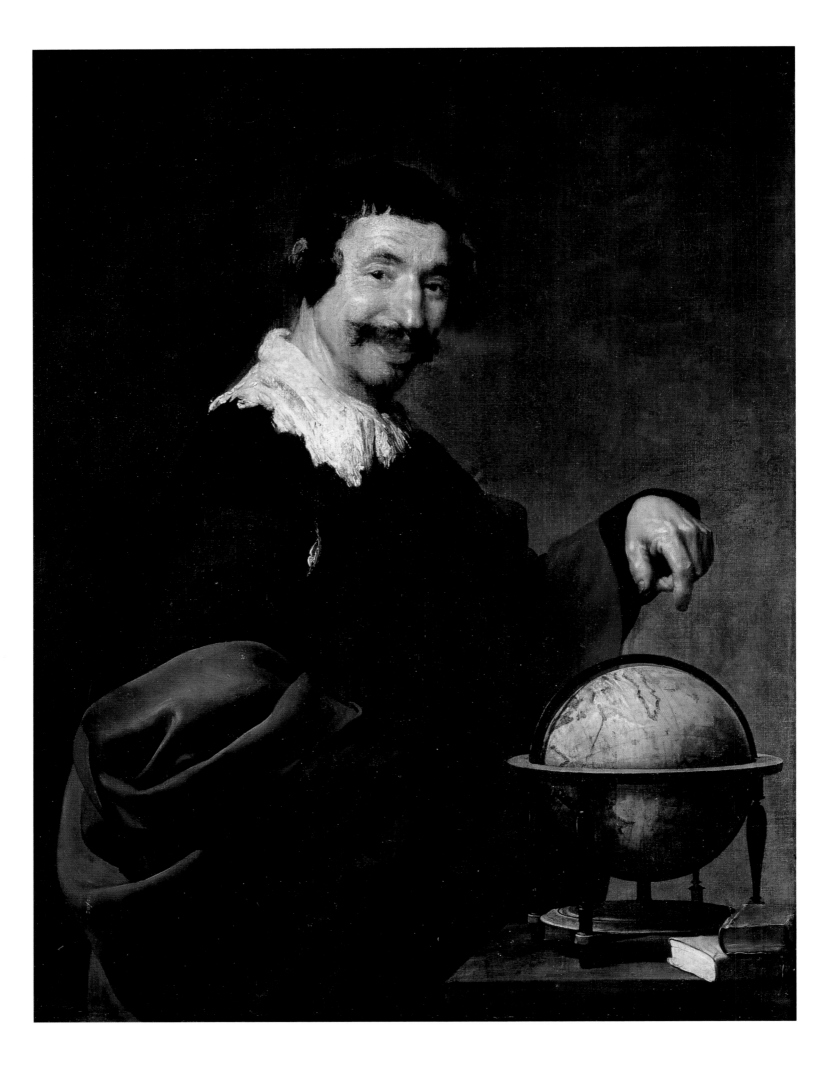

From Kitchen to Palace

Beneath a bushy, untidy moustache, teeth flash between sensual lips. The man in the picture (p. 6) stands there smiling, shown half-length, turned to one side but with his face towards us. His right hand is placed on his hip, in an attitude setting off the heavy folds of a red cloak. The thin little man's otherwise rather unimpressive figure and broad, quizzical face, his black doublet and his white lace collar all suggest the portrait of some humorous hidalgo or courtier of the seventeenth century. However, the subject of the painting is the Greek philosopher Democritus expressing his amusement at the world, which stands on the table in front of him in the shape of a globe.

Democritus, who lived around 470–360 BC, taught that cheerful and moderate contentment was the way to happiness. European painting of the Renaissance and Baroque periods repeatedly portrayed him as the "laughing philosopher", contrasting him with other intellectual types such as the pessimist, the stoic and the cynic. Peter Paul Rubens (1577–1640) painted a similar *Democritus* (p. 8) for the Duke of Lerma, to accompany a *Mourning Heraclitus*. From 1638 these two pictures were in the Torre de la Parada, the king of Spain's hunting lodge in the Pardo mountains near Madrid, for which Rubens and his pupils had painted mythological and hunting scenes ten years earlier. Velázquez, who had been a court painter since 1623, also worked on the decoration of the Torre de la Parada.

His own *Democritus* was painted in 1628/29, and his later alterations to the face and hands, softening their painting, show that at the time he was greatly interested in the work of the brilliant Flemish master of the Baroque. It is only in a few later works by Velázquez, such as the picture of Mars, the classical god of war, painted in 1639–1641 (p. 9), that the inspiration of Rubens is similarly evident.

Just as Rubens represents the culmination of Baroque painting in the southern Catholic Netherlands, Velázquez is pre-eminent among the artists of the *Siglo de Oro*, the "golden age" of Spanish painting. But unlike Rubens, who quickly rose to European fame, Velázquez remained relatively unknown outside his own country for a long time. One reason must have been that to a greater or lesser degree he avoided all those areas in which Rubens shone, and which particularly impressed patrons of high rank in the rest of Europe. Rubens specialized in the depiction of strong emotion, in large-scale altarpieces and historical pictures, and in the dynamic of form and narrative. Velázquez, on the other hand, paints no grand and apparently

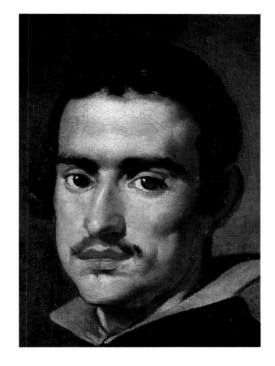

A Young Man (Self-Portrait?), 1623/24
Oil on canvas, 55.5 x 38 cm
Madrid, Museo del Prado

PAGE 6:
Democritus, 1628/29
Oil on canvas, 101 x 81 cm
Rouen, Musée des Beaux-Arts et de la Céramique

Peter Paul Rubens
Democritus, 1603
Oil on canvas, 179 x 66 cm
Madrid, Museo del Prado

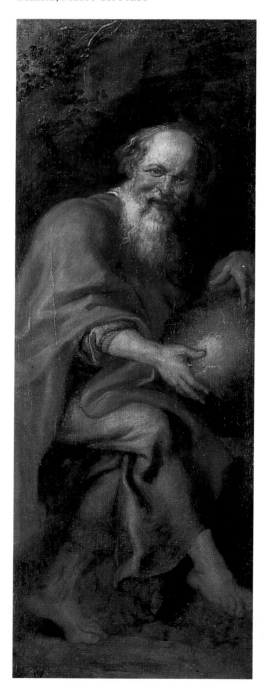

uncontrolled gestures; his compositions are generally filled with a sense of great calm.

As a colourist, Velázquez was in no way inferior to Rubens. In complete contrast to the latter, however, he dealt with the subjects of his paintings in a quiet, everyday manner, so that the artistic qualities of his direct and apparently straightforward style seem to be governed by a deeper and sometimes more mysterious kind of poetry.

Only in the course of the nineteenth century, when painting began to free itself from the constraints of literary subjects and realize its own creative potential, was the modernity of Velázquez in anticipating such developments recognized. Edouard Manet (1832–1883) called him the "painter of painters" ("Le peintre des peintres"), meaning that he appealed more to the eye than to the literary mind, and described what was once the iridescent grey of the background to the portrait of the court buffoon Pablo de Valladolid (p. 59 above left) as "perhaps the most remarkable piece of painting ever created". The Impressionists saw Velázquez as a precursor of the concept of pure vision, and elevated him to the artistic pantheon in the guise of a pioneer of modernity.

At the beginning of the sixteenth century the Iberian peninsula was on its way to becoming one of the richest regions of Europe, and it was the leading European power in the Counter-Reformation. The culmination of Counter-Reformation policies undoubtedly came during the reign of King Philip II (1556–1598). Under his successors, although there were symptoms of swift decline and economic crises shook the country, the glory of the *Siglo de Oro* concealed the harsh reality from outside eyes. In the reign of Philip III (1578–1621), literature flourished in the works of Miguel Cervantes and Lope de Vega. Philip IV (1621–1665) was more interested in painting than in dramatic literature, and he became the great patron of Velázquez.

In questions of artistic form Spain, like the rest of Europe, was entirely under the influence of Italy throughout the course of the sixteenth century. Ultimately, however, the Catholic Church came to occupy a predominant position during the decades of the Reformation and Counter-Reformation. It was the major source of artistic commissions, and could thus dictate what mystic subjects painters should depict, and in what styles. To reinforce its anti-Protestant stance yet further, after the turn of the century the Church demanded dramatically realistic art that no longer employed a complicated pictorial language or made difficult allegorical statements, but was easier to understand: art with which the general public could identify emotionally.

Diego Velázquez was born in Seville in 1599, to parents who belonged to the lesser nobility. When he was twelve he probably began studying with Francisco de Herrera the Elder (c. 1590–1654), a hot-tempered man whose studio he soon left for the workshop of Francisco Pacheco (1564–1644), later to be his father-in-law. Pacheco was a painter of moderate talent, but well versed in the theory of art and a tolerant teacher, and he had excellent connections with the artists, intellectuals and nobility of Seville.

The artistic school of Seville was the most important in Spain during the first half of the seventeenth century. Francisco de Zurbarán (1598–1664) conjured up an atmosphere of mystic and visionary piety in his pictures for the cloisters and churches of monasteries; Bartolomé Esteban Murillo

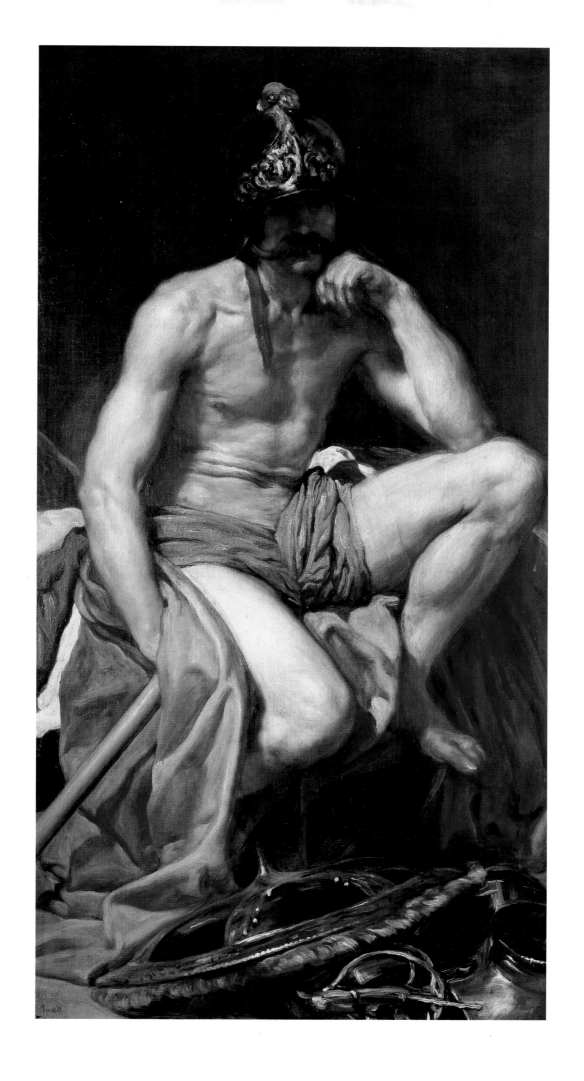

(1617–1682) depicted the life of simple folk: the beggars, vagabonds and street children who were symptomatic of social decline in what still appeared to be a flourishing metropolis. Seville's cosmopolitan patrons of art, buyers from the merchant class which included Genoese, Flemings and, towards the end of the century, Netherlanders, provided artists with an unprecedented opportunity to paint works on both sacred and secular themes.

The public of Seville greatly appreciated the *bodegones* genre. The *bodegón* is not just a still life; it originally depicted a tavern or cookhouse, or showed ordinary people in settings where food and drink figured prominently. At the same time these superficially ordinary subjects often concealed allegorical, moral or religious meanings. Since the southern Netherlands had remained under the rule of the Spanish Habsburgs, artistic influences from that region, such as the kitchen scenes of Pieter Aertsen (1508–1575) and Joachim Beuckelaer (c. 1530–1573), had a lasting effect on Spanish artists. During his Seville period, between 1617 and 1622, Velázquez painted nine *bodegones*, and they mark the beginning of his career.

Old Woman Frying Eggs, 1618
Oil on canvas, 100.5 x 119.5 cm
Edinburgh, National Gallery of Scotland

An interesting feature of this picture, the main subject of which is the cooking of eggs in a clay pot, is the honeydew melon with a cord slung crosswise around it, making it resemble an imperial orb.

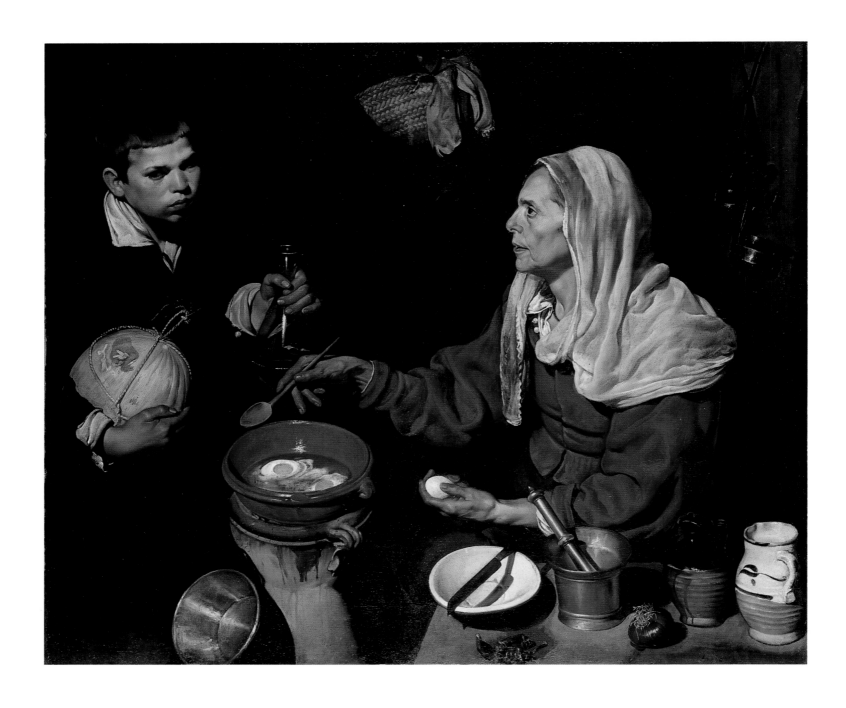

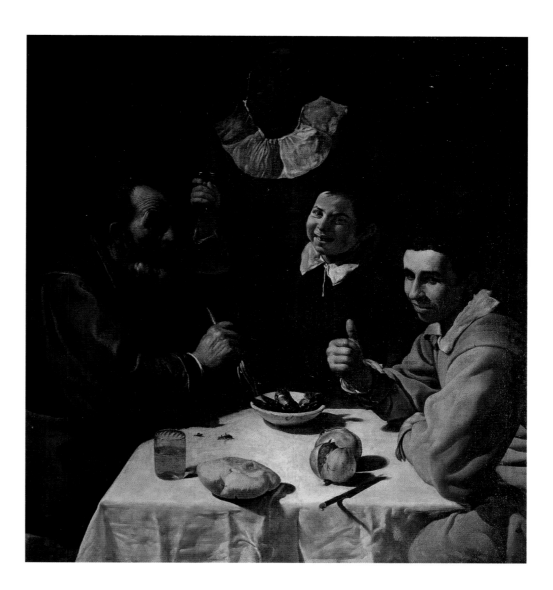

Three Men at Table, c. 1618
Oil on canvas, 108. 5 x 102 cm
Saint Petersburg, Hermitage

The *Old Woman Frying Eggs*, dated 1618 (p. 10), shows an elderly cook sitting in front of a small clay vessel in which she is cooking eggs over a charcoal fire. The worn but fine features of her face, beneath the confident painting of the veil on her head, bear witness to a life well lived. There is a serious, meditative quality about the woman's figure, and the boy with the melon under his arm and a carafe of wine in his hand looks out of the picture at us with comparable gravity. The contrast of youth and age conveys the transience of life, and the egg in the woman's hand suggests associations, familiar at the time, with the mutability of all earthly matter and with another life beyond the grave. The background is dark and indistinct, in contrast to the often over-crowded backgrounds of Dutch kitchen scenes.

The *Three Men at Table* (ill. above) is among Velázquez' earliest *bodegones*, painted shortly before the end of his apprenticeship, in 1617 or at the very beginning of 1618. It concentrates with particular intensity on the individual characterization of the men, who are shown half-length and three-quarter length. Again, they are of different ages. The frugality of their meal obviously does not impair their enjoyment of life. The composition presents a view from above of their expressive faces and hands, the table-cloth, and the physical materiality of the food and drink.

Velázquez did not paint lavish quantities of victuals, but the frugal diet of simple people: there is garlic on his tables, with fish and eggs, black

pudding, olives and aubergines, cheese, home-made wine and a few fruits, together with kitchen utensils such as a mortar, a bowl or a pottery jug. These Spartan still lifes and the realistically depicted characters shown in such settings, people with an aura of grave silence even when they are painted in action, convey a sense of self-sufficiency that seems to emanate from the down-to-earth philosophy of the ordinary man in the street.

Naturally enough, then, in his *bodegones* Velázquez followed an artistic tendency of the early seventeenth century that had made a deep impression on many parts of Europe, but particularly Spain, with its radically revolutionary depiction of the directly vivid and graphic. It derived from the painting of the Italian artist Caravaggio (1573–1610). Caravaggio was totally opposed to the idealistic atmosphere and cult of beauty of the Italian Renaissance. Not only did he allow the lower classes with their rough physicality, coarse, dull-coloured clothing and bare, dusty feet to participate in the story of Christian salvation; even more provocatively, in his altarpieces he made the saints themselves conform to his empirical approach, endowing their faces and bodies with lines and wrinkles, with the signs of old age and suffering. Velázquez too made much use of Caravaggesque chiaroscuro in his early pictures. However, the Spaniard turned the Italian artist's almost aggressive realism into a sharpness of perception that is softened by such picturesque devices as strangely new colours, always in earthy hues, and by his equating of objects and humans in a manner suggesting the experiences of dreams.

A particularly fine example of this approach is Velázquez' first real masterpiece, the *Waterseller* (ill. left) painted around 1620. An old man whose poor clothing and sharply lit profile are ennobled by the light falling on him is handing a boy a glass of water; the fig shown in the water was thought to make it taste fresher. The forceful way in which the two jugs, shining in the light, make their presence felt in the foreground, the brilliance of the sparkling drops of water on the curve of the larger pitcher, and the beautiful transparency of the glass (see detail p. 13) match the physical and mental qualities suggested by the three human figures. Dignified as this setting is, however, contemporary viewers would maybe also have seen an unmistakably burlesque side to it, for a Sevillian water carrier is described in a scene reminiscent of this picture by Velázquez in one of the picaresque novels so popular at the time, books which held up a mirror to Spanish society in the same way as some of the stories of Miguel de Cervantes.

No one thought it beneath the young Velázquez to concern himself with such "low" themes. On the contrary: Francisco Pacheco cited the example of the classical artist Piraikos, who bore the nickname "Rhyparographos" because he painted similarly ordinary subjects, saying that in reviving his artistic world Velázquez had achieved an exact imitation of nature, which was the basis of all good art. Such an attitude to the subject in Spain also made it easy for artists to merge the *bodegón* with more "elevated" pictorial genres: religious stories or mythological scenes.

Velázquez united different stylistic genres in this way for the first time in 1618, with *Christ in the House of Martha and Mary* (pp. 14/15). The foreground depicts an interior with the large, half-length figures of two women, one old and one young; the younger is working with a mortar set on the table in front of her. Garlic, fish, eggs, seasonings and a jug form a still life emphasized, like the faces of the women, by the light falling on it.

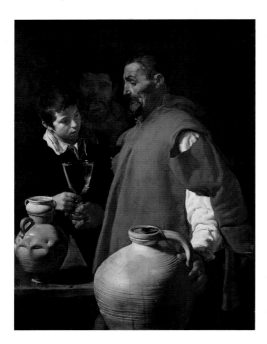

The Waterseller, c. 1620
Oil on canvas, 106.7 x 81 cm
London, Apsley House, Wellington Museum, Trustees of the Victoria and Albert Museum

The custom of adding a fig – such as the fruit visible at the bottom of the glass (see detail p. 13) – to water to make it taste fresher is said to be still current in Seville today.

PAGES 14/15:
Christ in the House of Martha and Mary, 1618
Oil on canvas, 60 x 103.5 cm
London, The Trustees of the National Gallery

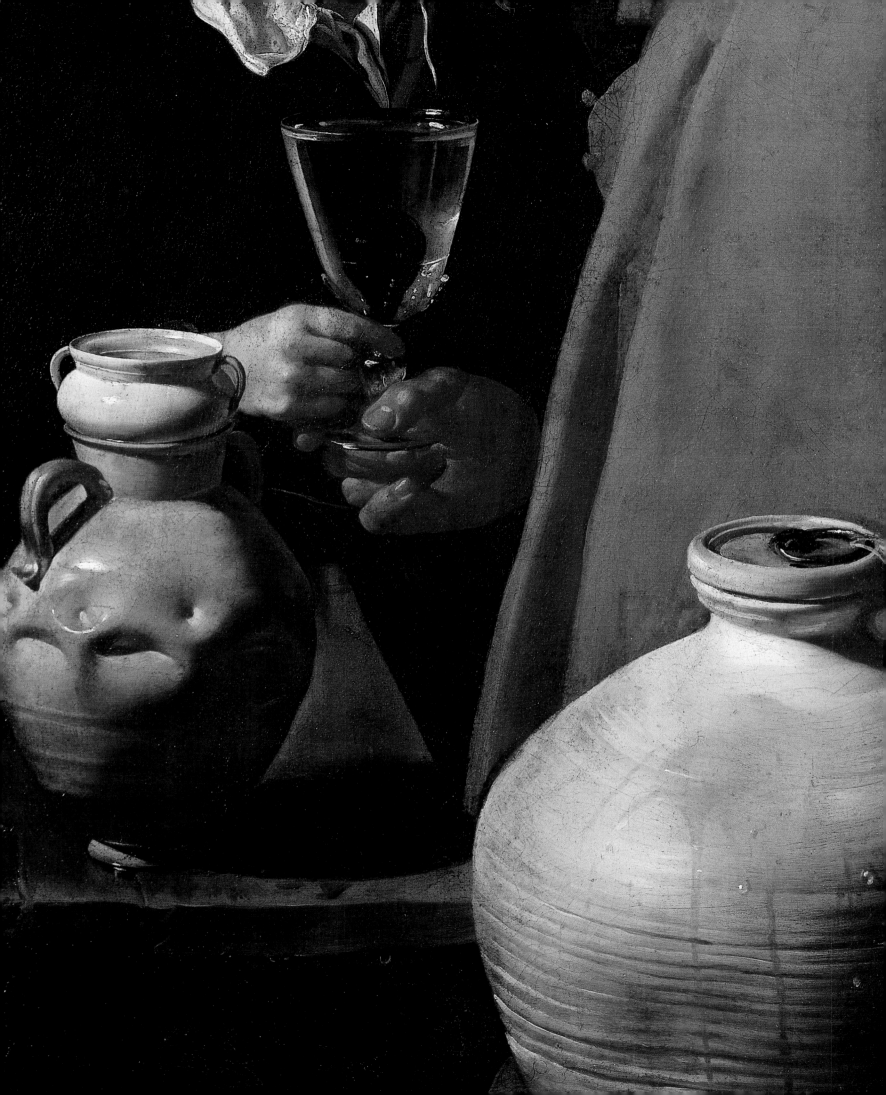

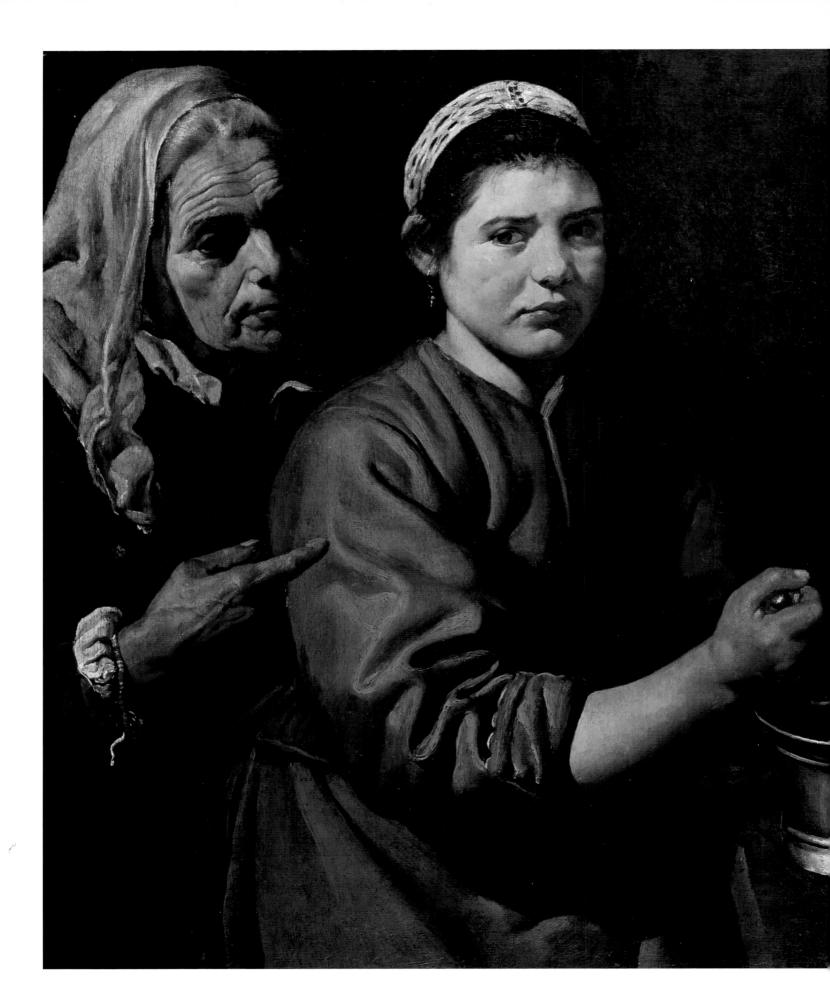

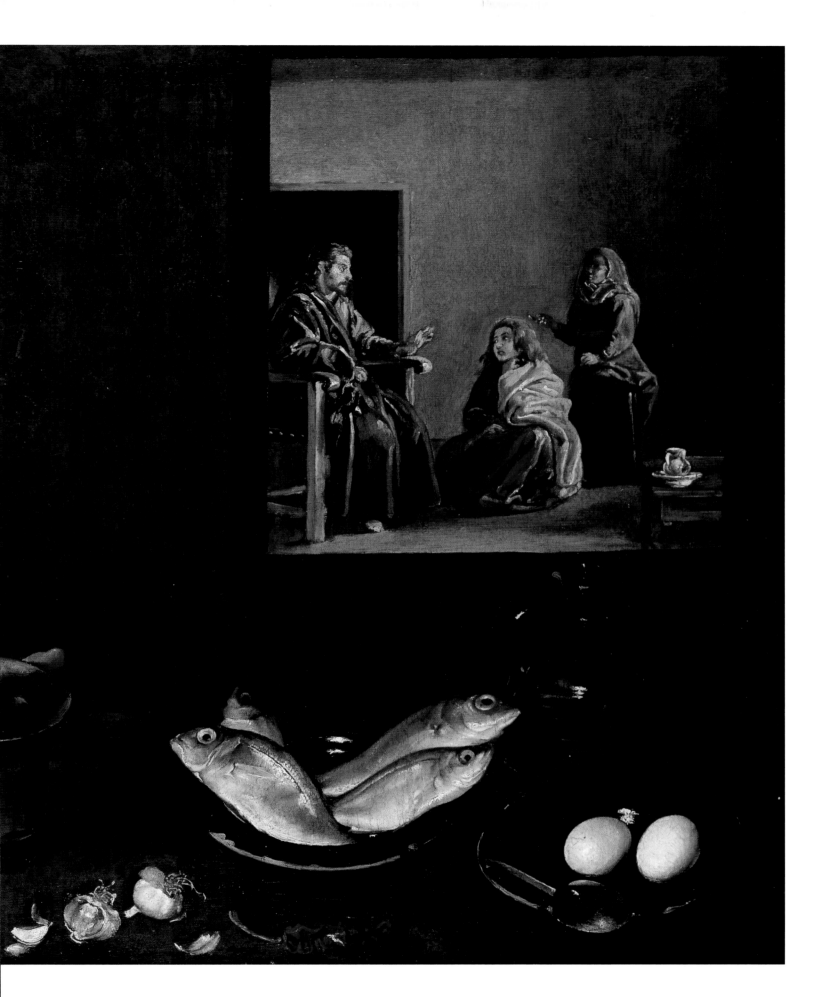

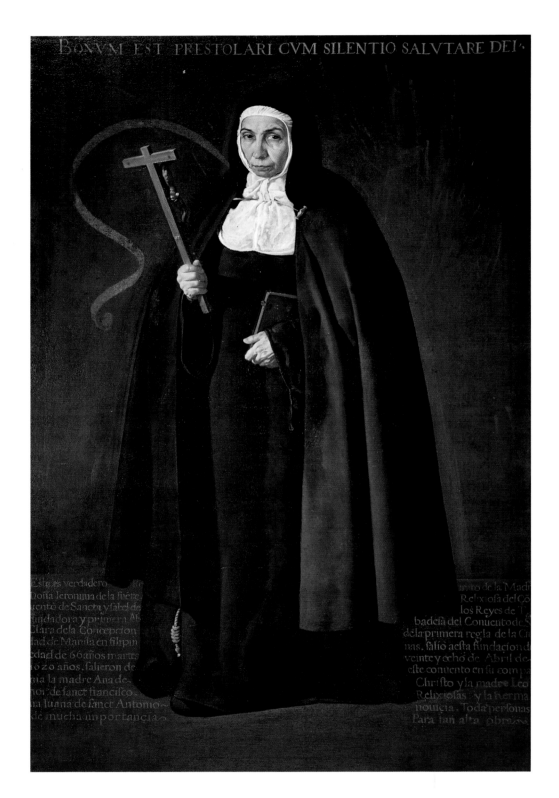

Mother Jerónima de la Fuente, 1620
Oil on canvas, 162 x 107.5 cm
Madrid, Museo del Prado

PAGE 17:
The Adoration of the Magi, 1619
Oil on canvas, 204 x 126.5 cm
Madrid, Museo del Prado

The main characters are thought to be portraits: the young king is a free self-portrait of the artist, while the kneeling king behind him has the features of Pacheco and the Virgin Mary those of Pacheco's daughter Juana, married to Velázquez.

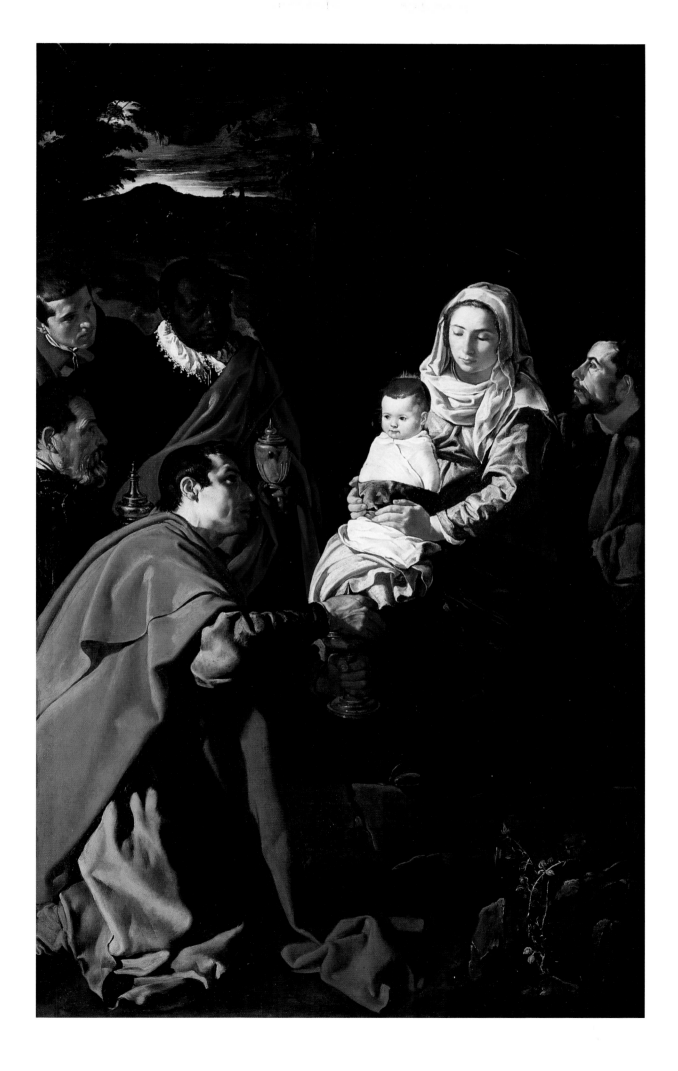

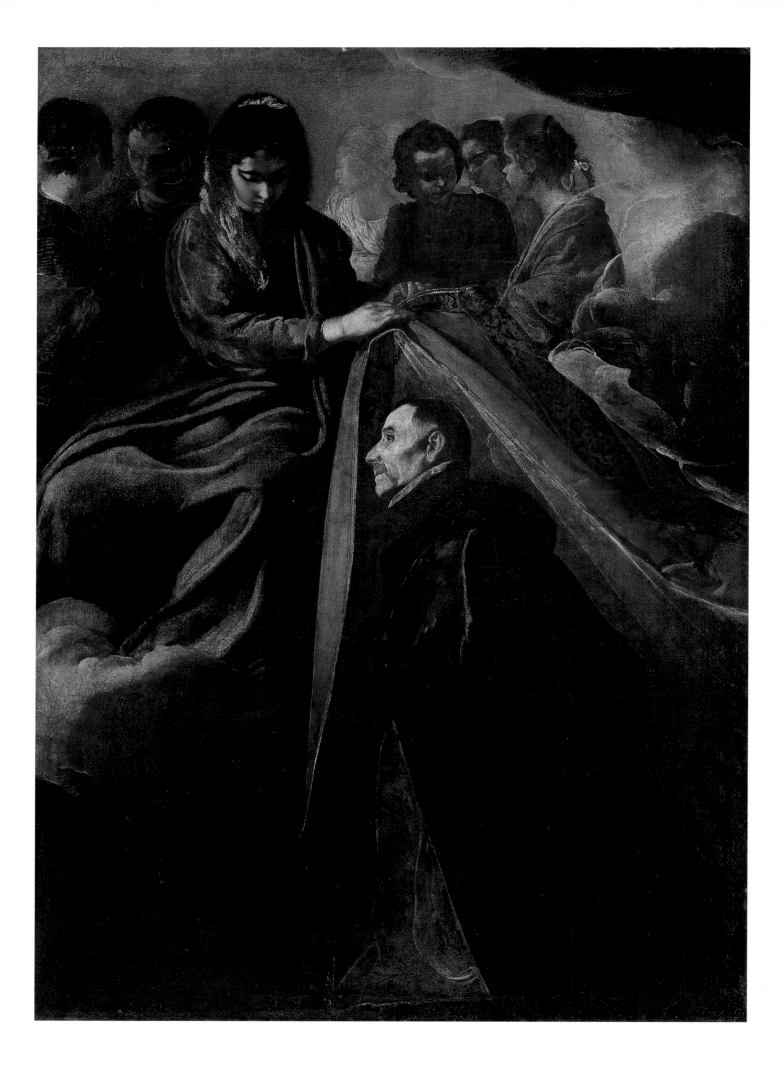

Head of a Girl, c. 1618
Chalk drawing, 15 x 11.7 cm
Madrid, Biblioteca Nacional

El Greco
St. Paul, 1608–1614
Oil on canvas
Toledo, Casa y Museo del Greco

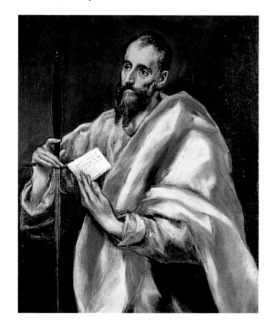

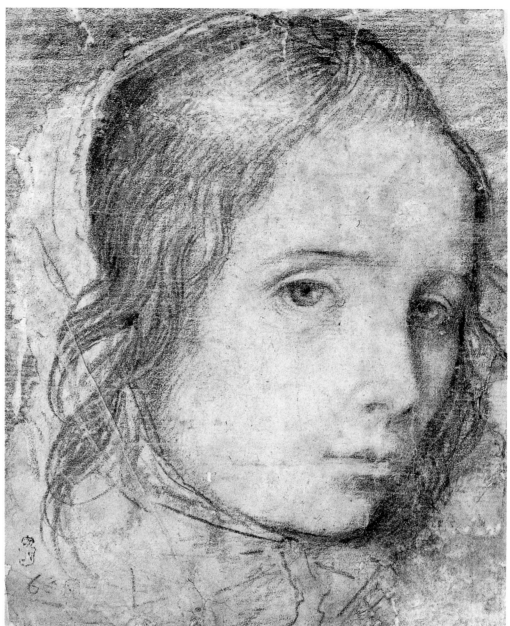

PAGE 18:
St. Ildefonso Receiving the Chasuble from the Virgin, c. 1620 (?)
Oil on canvas, 166 x 120 cm
Seville, Museo de Bellas Artes

It remains curiously uncertain whether the religious scene on the right in the background, from which the work takes its title, is a picture, or a reflection, or seen through an open hatch in the back wall of the room in the foreground. But in any case the artist is playing with levels of reality, with "pictures within a picture" reflecting and commenting on each other, questioning the interplay of their statements – a device that Velázquez was to employ again in his late masterpiece, the *Meninas*, where he refined it to the utmost (pp. 86–91).

The sublimity of the main religious subject of Christ with the two sisters in Bethany is banished to a small area in the background, while the down-to-earth subsidiary theme of the kitchen scene occupies the foreground. Velázquez is not setting out to tell a Biblical story, but to establish connections between the religious parable and the everyday life of his own time: the food on the table is obviously part of a Lenten meal being prepared by the young maidservant, while the old woman's pointing hand is telling the girl that – as the Biblical scene behind them states – industry

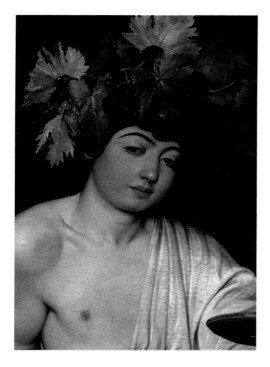

Caravaggio
Bacchus (detail), c. 1598
Oil on canvas, 98 x 85 cm
Florence, Galleria degli Uffizi

While Caravaggio's fleshy Bacchus is almost Buddha-like in appearance, Velázquez painted the same subject in a considerably more rustic manner.

Jusepe de Ribera
Archimedes (detail), 1630
Oil on canvas, 125 x 81 cm
Madrid, Museo del Prado

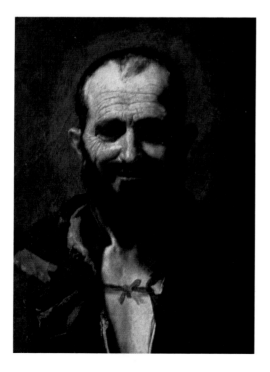

and work (the *vita activa*) are not enough in themselves for true piety, which also requires serious contemplation and the strength of faith (the *vita contemplativa*).

But in *The Adoration of the Magi* (p. 17), probably painted in 1619 for the Noviciate of the Jesuits of San Luis in Seville, Velázquez moves completely away from the approach of the *bodegones*. Although striking chiaroscuro contrasts still predominate, and secular elements mingle with the sacred atmosphere, the focal point of the picture is the radiantly idealized presentation of the Madonna and Child. The composition is traditional, although Velázquez rejects the artificial affectation of earlier Spanish paintings of this particular subject. He conveys dignified calm in a lofty and spiritual pictorial concept.

No doubt Pacheco, who advised the Inquisition on artistic matters in 1619, will have encouraged his pupil and son-in-law to immerse himself in religious subjects. Velázquez painted a whole series of altarpieces and devotional pictures in Seville, and even later he did not neglect sacred painting entirely, but it was never to be at the centre of his artistic activity. That place was reserved for the portrait.

Even in Seville, where he was accepted into the painters' guild of St. Luke before he was eighteen and then, in 1620, opened a workshop and employed apprentices himself, he was already embarking on portraiture, a path that would lead him to a place among the major portraitists in the history of art. There are around half a dozen portraits extant of very different people from Velázquez' early period in Seville, including two sensitive drawings vibrant with life, both showing a young girl and dated to 1618 (p. 19). Since very few of the artist's authentic drawings have survived, these two are particularly worthy of notice.

One of his series of unforgettable portraits showing great psychological acuity, and among the few works to be dated and signed by the young artist, is *Mother Jerónima de la Fuente*, of 1620 (p. 16). The picture must have been painted before 1 June that year, when the Franciscan nun it depicts took ship for the Philippines to found the convent of Santa Clara in Manila. The elderly nun's gaze is keen and slightly melancholic, as if prepared for any sacrifice. She holds a large crucifix in her right hand and a book in her left hand.

Velázquez took up ideas from earlier models that struck him as important and worth studying. In religious compositions such as the painting *St. Ildefonso Receiving the Chasuble from the Virgin* (p. 18, probably painted about 1620), the spiritual ascetics portrayed by El Greco (1541–1614) may well have been such models. With remarkable self-confidence, however, Velázquez always transformed the ideas he adopted into his own inimitable style. Its increasing artistic delicacy, his sure touch in exploring the depths of his subject, and a fine sense of composition show the presence of genius beneath the surface of the young artist still learning his craft.

At the beginning of the seventeenth century, the Spanish court was still based in Valladolid. Around 1620 it moved to Madrid, and in 1622 Velázquez went there for the first time. He wanted to get a footing in the city, the centre of power and a place where he might hope to find distinguished patrons. Pacheco's connections with courtiers, and the Sevillian origin of the Count of Olivares (to whom Philip IV, who was only seventeen years old, had entrusted the business of state on coming to the throne),

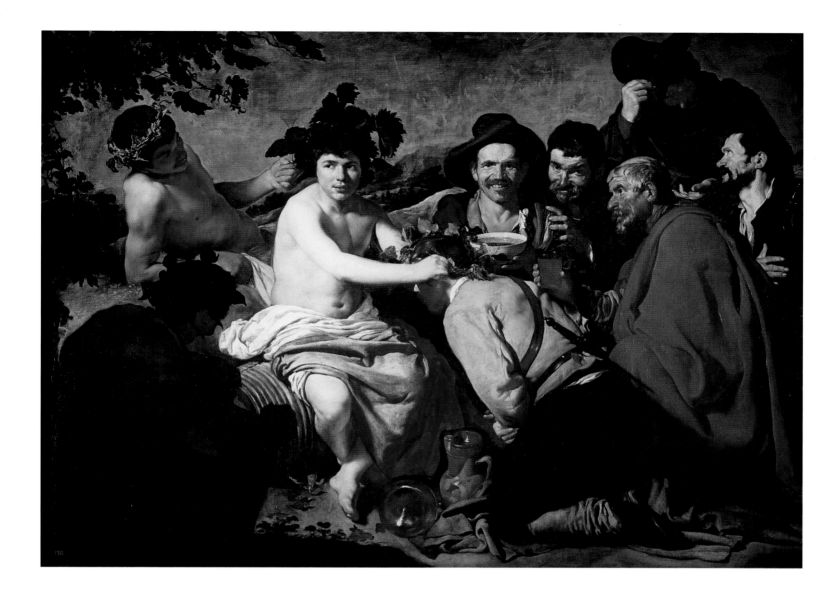

Bacchus, 1628/29
Oil on canvas, 165.5 x 227.5 cm
Madrid, Museo del Prado

It was thought in the nineteenth century that this was a realistic scene showing a country festival, and the picture was given the title *The Drinkers*. The painting was damaged in the fire that destroyed the royal palace in Madrid in 1734, and the left half of the god's face has been much restored.

must have been conducive to the success of this venture, and indeed success quickly followed. After the death of Rodrigo de Villandrando, the king's favourite among the four court painters of the time, Velázquez received a summons to court from the Count of Olivares in the spring of 1623.

The artist, then just twenty-four, returned to Madrid and entered the king's service. He had thus embarked upon the period that would be of the greatest importance to his career. Besides his *bodegones*, generally popular despite adverse criticism of them by a rival court painter, Vicente Carducho (1570–1638), it was his mastery of portraiture that the king appreciated – and it also aroused the envy of his colleagues. Their hostility reached a peak when Philip IV organized a competition between the court painters. Velázquez emerged the winner, and was rewarded by an appointment to the rank of Usher of the Chamber.

The artistic reasons for his steady professional progress are made very clear by the picture of *Bacchus* (ill. above) painted at the king's wish in 1628/29. Bacchus, the classical god of wine and orgiastic pleasure, is shown here in an outdoor setting, half unclothed, the plump flesh of his naked torso shining almost sickly white in the light, and pressing a wreath of ivy on the head of a peasant who kneels before him. This parody of a

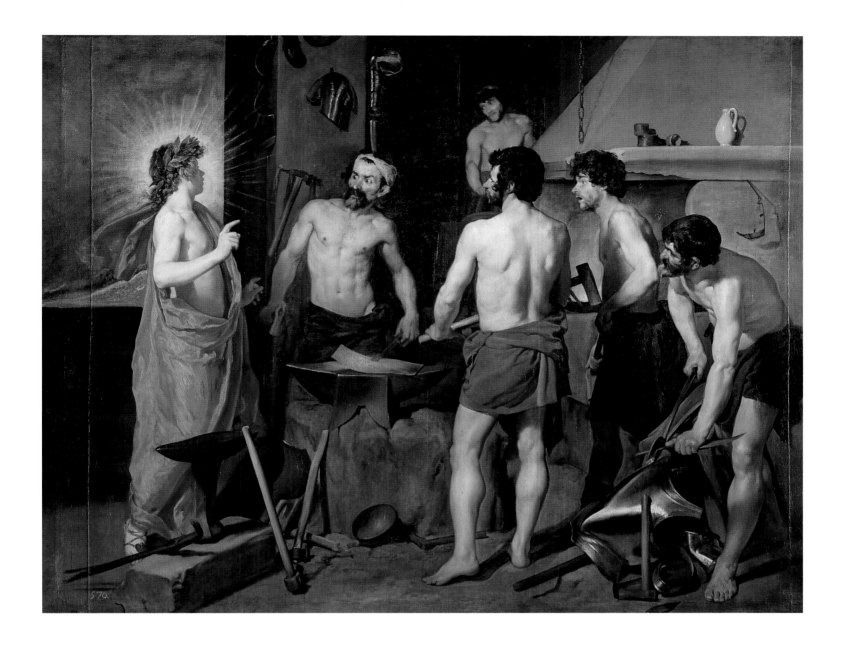

coronation is being watched, partly with amusement and partly, it would seem, with reverence, by other rustic figures pressing close to the god as if he were one of themselves. The peasants in this picture are not, as was so often the case in the literature and painting of the time, to be looked upon as oafish clods contrasting with an elegant, idealized world. Instead, they are depicted as people whose hard work creates the basis of social prosperity, and in reward the god solemnly presents them with the joys of wine.

Velázquez remains faithful to the *bodegón* tradition in many of the details of this picture, clearly showing the continued importance of the example of Caravaggio – whether in directly adopting a subject (p. 20 above) or as conveyed through the figures of human types painted by Caravaggio's Spanish follower Jusepe de Ribera (1591–1652; p. 20 below). However, Ribera himself, who painted his major works for the viceroy of Naples, illustrates the fact that ultimately the Caravaggesque style seemed too plebeian to maintain its place at court.

Consequently, Velázquez too had to adopt a different approach and take his guidelines from other models. At the time of the *Bacchus*,

The Forge of Vulcan, 1630
Oil on canvas, 223.5 x 290 cm
Madrid, Museo del Prado

The search for possible models for this composition, as with other works, has produced no really convincing results. Velázquez obviously treated potential sources with great freedom, and never borrowed from them directly.

PAGE 22:
Study for the Head of Apollo in "The Forge of Vulcan", 1630
Oil on canvas, 36.3 x 25.2 cm
Japan, private collection

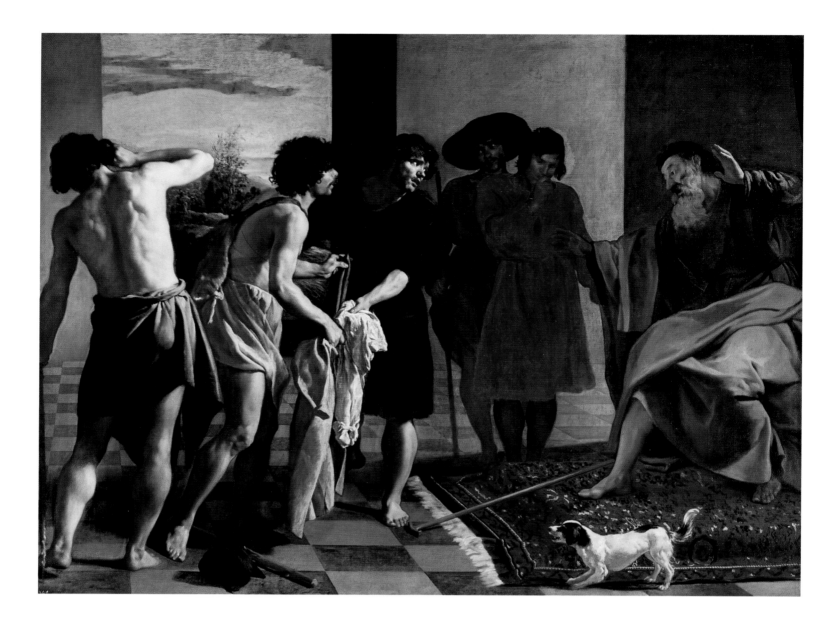

The geometry of the tiles on the floor divides
up the space in a way that Velázquez may have
learnt from a book in his private library, pub-
lished by Daniello Barbaro in Venice in 1568
and entitled *Pratica della Prospettiva*, or from
other Renaissance works on theory, or from
such sources as the pictures of Tintoretto.

Rubens, who visited Madrid for the second time in 1628 and painted com-
positions of his own for the king, inspired the young court painter to em-
ploy a much brighter palette and more spontaneous brushwork than before.
Velázquez' brushwork in particular was to be heightened to an almost
Impressionist freedom in his later works.

However, it was chiefly in Italy that Velázquez expected to find the
inspiration that would lead him into new artistic territory. In 1629 the king
gave him paid leave to make this journey of creative discovery. His ship
landed in Genoa, and a few days later Velázquez set off for Milan and
then Venice, where he saw works by Tintoretto (1518–1594) and Titian
(c. 1485/90–1576). He went on to Rome, probably by way of Florence, and
spent a year in the capital studying the works of Raphael (1483–1520) and
Michelangelo (1475–1564).

The pictures Velázquez produced in Italy presumably include his two
small topographical studies, vividly painted and surprisingly Impressionist
in effect (pp. 26 and 27), as well as the large *Forge of Vulcan* (p. 23). A
preparatory study of a head for the main figure in this picture is extant
(p. 22). The god of fire and his assistants are working a red-hot piece of
metal in the forge, which is grey with dust, and another journeyman is mak-

ing a suit of knightly armour, its materiality depicted with a masterly touch, when Apollo the god of light makes his entrance, rather like the youthful hero in a provincial farce – yet radiant as his appearance may be, he brings Vulcan unwelcome news: at this very moment, as we know from mythology, Vulcan's wife Venus is keeping an amorous tryst with Mars, the god of war.

The half-naked figures, shown in richly graduated flesh tints and not, as in the *Bacchus*, pressed close together in a dense group, are depicted in postures noticeably influenced by sixteenth-century Italian masters. Although large areas in earthy colours are still reminiscent of Caravaggio, the greater vigour of the brushwork and the red of Apollo's robe, which is suffused with light, suggest those models now admired by Velázquez: Tintoretto, the Venetian master of colour, and in particular Titian. Inspired by his study of Titian, but never lapsing into mere imitation, Velázquez has softened his line, for instance in the religious painting *Joseph's Bloody Coat Brought to Jacob* (p. 24), which was also completed in Rome in the year 1630. These influences are clearly illustrated by the detail of the little dog in the foreground of the picture (ill. below), a feature often found in Tintoretto.

The composition of this picture portrays the dramatic climax of the Biblical story, when the garments of Joseph, sold into slavery by his brothers, are dipped in the blood of a goat and shown to his old father Jacob, to make him believe that his favourite son is dead. The physical reactions of the participants in this grim story are very forcefully depicted. The setting

Detail from *Joseph's Bloody Coat Brought to Jacob*, 1630

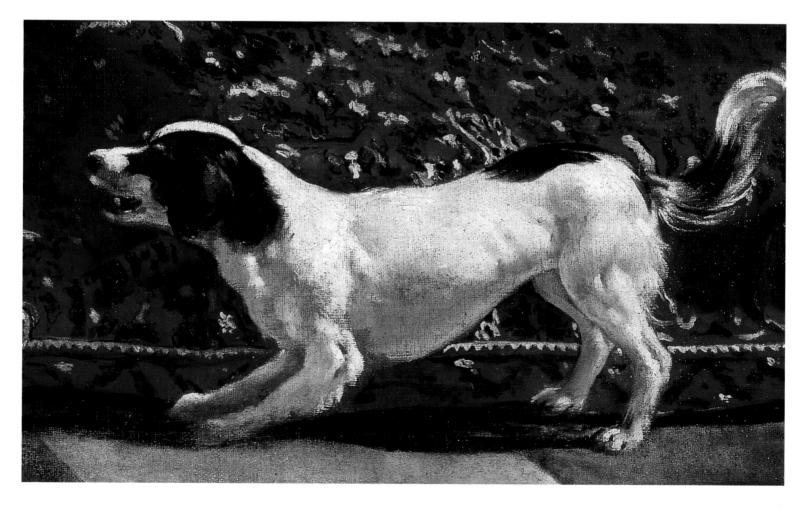

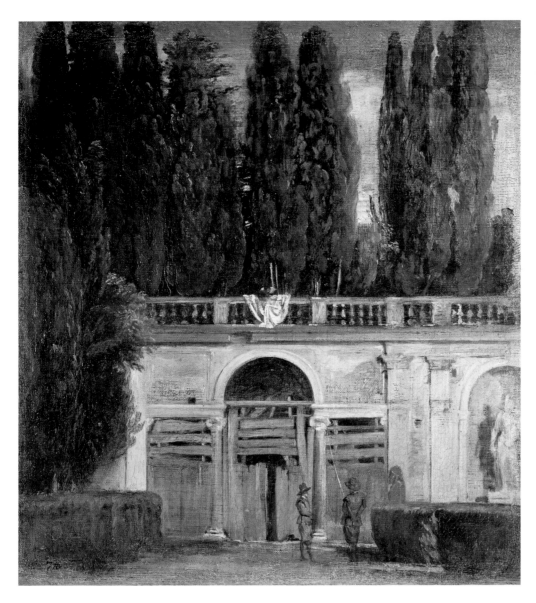

Villa Medici in Rome (Pavilion of Ariadne), 1630
Oil on canvas, 44.5 x 38.7 cm
Madrid, Museo del Prado

Although Velázquez enjoyed life in Rome during his first visit to Italy, he feared the summer heat in the city, and consequently in May 1630 withdrew for two months to the secluded Villa Medici, which was also an ideal place for him to pursue his studies of classical antiquity.

is a large hall with its floor tiled in a chessboard pattern, a frequent element in the works of both Titian and Tintoretto. In the background, there is a view of a beautifully painted landscape.

Velázquez' travels in Italy soon came to an end. After visiting Jusepe de Ribera in Naples, he returned home – that is to say, to the court in Madrid – in 1631. He was immediately commissioned to paint the portrait of little Prince Baltasar Carlos (p. 34), a task that the king had not wished to entrust to anyone else during the absence of the artist, who was now his favourite court painter.

Villa Medici in Rome
(Façade of the Grotto-Logia), 1630
Oil on canvas, 48.7 x 43 cm
Madrid, Museo del Prado

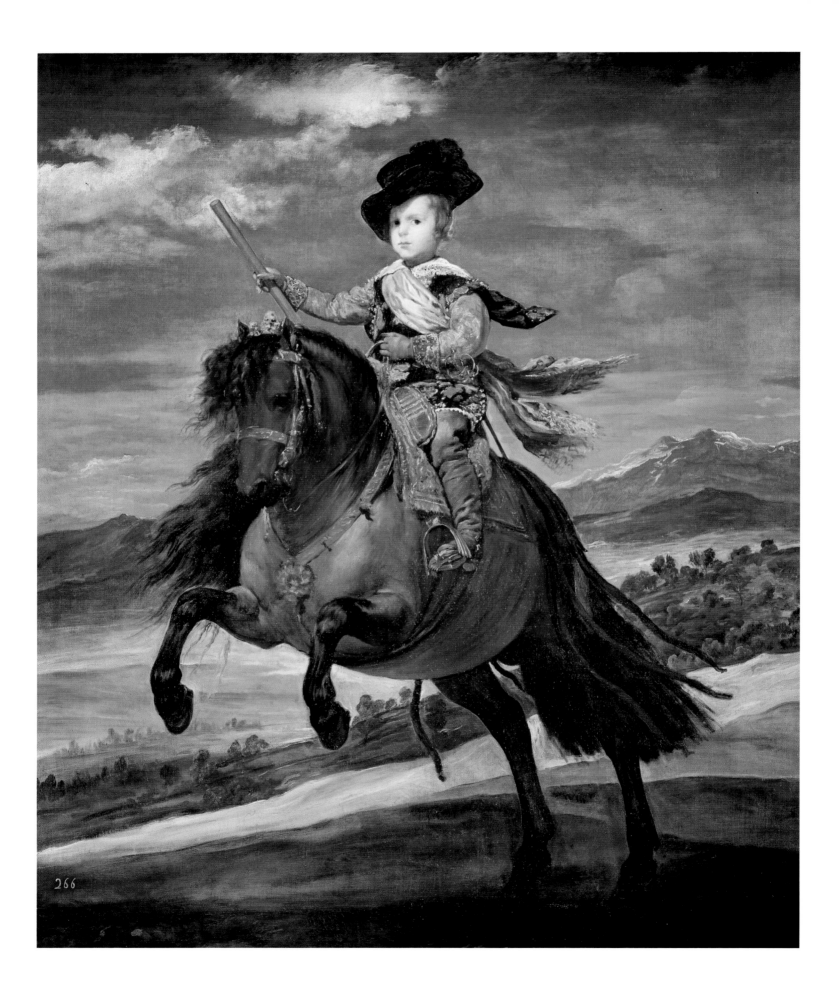

266

The Psychology of Power

When Velázquez was appointed court painter in Madrid in 1623, his principal task was to paint portraits of Philip IV, a duty that he performed to perfection. The Count of Olivares went so far as to say that by comparison with Velázquez no one had ever yet painted a "real" portrait of the king: that is to say, so striking and impressive a likeness of him. The portraits of the Spanish Habsburgs painted in profusion by Velázquez are surely among the finest and best examples of court portraiture in the history of European art.

The artist, who had no chance of developing such a wide range of activities as his colleagues in Paris and Rome, breathed life into the conventional rigidity of the portrait by adopting a new artistic viewpoint of greater profundity, not least during his first journey to Italy. His kings and princes are of course still presented as representatives of their exclusive social rank, and their ceremonial bearing is the same as before, but their individuality shows in their faces and hands.

Philip IV in Armour, a portrait of the period around 1628 (p. 30 left), over-painted and cut to its present size at a later date, presupposes the existence of a model such as the portrait of the king in parade armour painted around 1623 (p. 30 right), probably by Juan Bautista Maino (1578–1649). This picture by Philip's Italian-trained drawing master also shows the subject in a lifelike attitude, but the modelling of the face in Velázquez' portrait is much more expressive, and its extrovert clarity shows up more impressively in contrast to the sash draped decoratively over the armour and painted in many shades of red.

When the Infanta Doña María, daughter of Philip III and Queen Margarita, set out for Vienna in December 1629 to meet the husband who had been chosen for her long before, the king of Hungary, later Emperor Ferdinand III, her journey included a stay of several months in Naples in 1630. Velázquez made haste to Naples to portray his sovereign's sister, who was famous for her beauty (p. 31). He worked with the utmost care to emphasize the enamel-like smoothness of her fine features. Every detail, for instance the typically protuberant Habsburg lower lip, shows a striking similarity to the living model. The delicate carmine of her lips, the beautiful Titian shade of her hair, depicted in relaxed brushstrokes with dark brown shadows and bright yellow highlights, all display the artistic skill now at the command of Velázquez in his harmonious combination of state splendour with the individuality of his sitter. The carefully modelled face in this head-and-

Detail from *Philip III on Horseback*,
c. 1634/35
(see ill. p. 38)

PAGE 28:
Prince Baltasar Carlos on Horseback,
1634/35
Oil on canvas, 209.5 x 174 cm
Madrid, Museo del Prado

Juan Bautista Maino
Philip IV in Parade Armour, c. 1623
Oil on canvas, 198.1 x 118.1 cm
New York, The Metropolitan Museum of Art

Philip IV in Armour, c. 1628
Oil on canvas, 58 x 44.5 cm
Madrid, Museo del Prado

shoulders portrait was to serve as the basis for several full-length portraits of the Infanta, workshop copies that may have been intended as gifts to royal residences abroad; one is in Berlin today (p. 31).

The portrait of *Philip IV in Brown and Silver* (p. 32) was painted soon afterwards. The unattractive matt white of the stockings is the result of an unskilful restoration of the picture in 1936, but otherwise the work is a good example of the skilled manner that Velázquez had now mastered. The restriction of surrounding areas and the general pose found in earlier portraits of the king are still present, but the subject's whole attitude is more relaxed, the flesh tints, probably under the influence of Rubens, are painted with more fluidity, the accents of colour – eyes gleaming like black tortoiseshell, the golden lights on the waves of the hair – are placed with more emphasis, and shapes conveying Baroque dignity, such as the profuse folds of the red curtain, have made their way into the formerly sparse interior. Above all, Velázquez' new delight in luxuriant colour is reflected in his de-

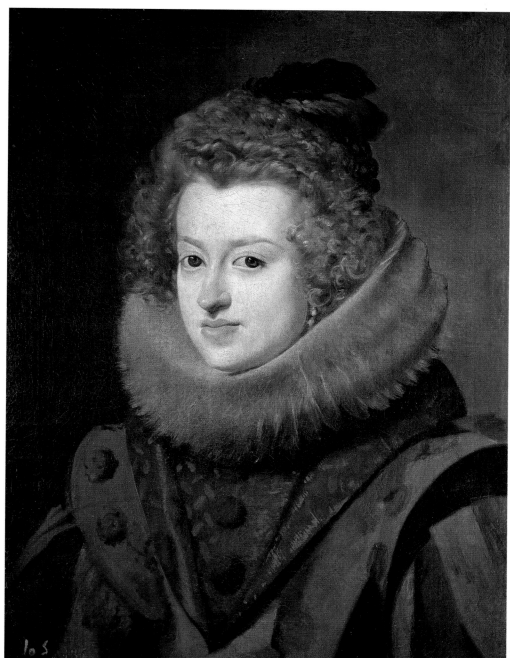

Infanta Doña María, Queen of Hungary,
1630 (?)
Oil on canvas, 59.5 x 45.5 cm
Madrid, Museo del Prado

Workshop of Velázquez
Infanta María, Queen of Hungary,
c. 1628–1630
Oil on canvas, 200 x 106 cm
Berlin, Staatliche Museen zu Berlin –
Preussischer Kulturbesitz, Gemäldegalerie

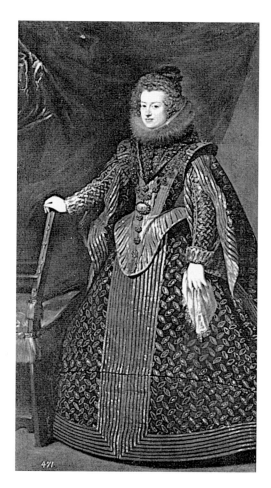

piction of the silk embroidery and the silver and brown tones of the king's clothing.

The picture of *Queen Isabel, Standing* (p. 33) is similar in its composition – although the queen is facing the opposite way – and constructed with equal care. Velázquez painted the queen between 1631 and 1632. She was the daughter of King Henry IV of France and Marie de Medici, and had married Philip IV in 1615, before he came to the throne. The artist devoted the utmost ingenuity to painting the queen's robes. Besides depicting all the material splendour shown in this picture, he was interested, as so often in later paintings, in the wealth of nuances to be conveyed by the play of light on black fabrics, which he often exaggerated to produce glittering reflections.

Art-lovers of his time also appreciated that effect in the works of the Dutch painters Rembrandt (1606–1669) and Frans Hals (1581/85–1666). It seems that this technique was something Velázquez mastered only after his

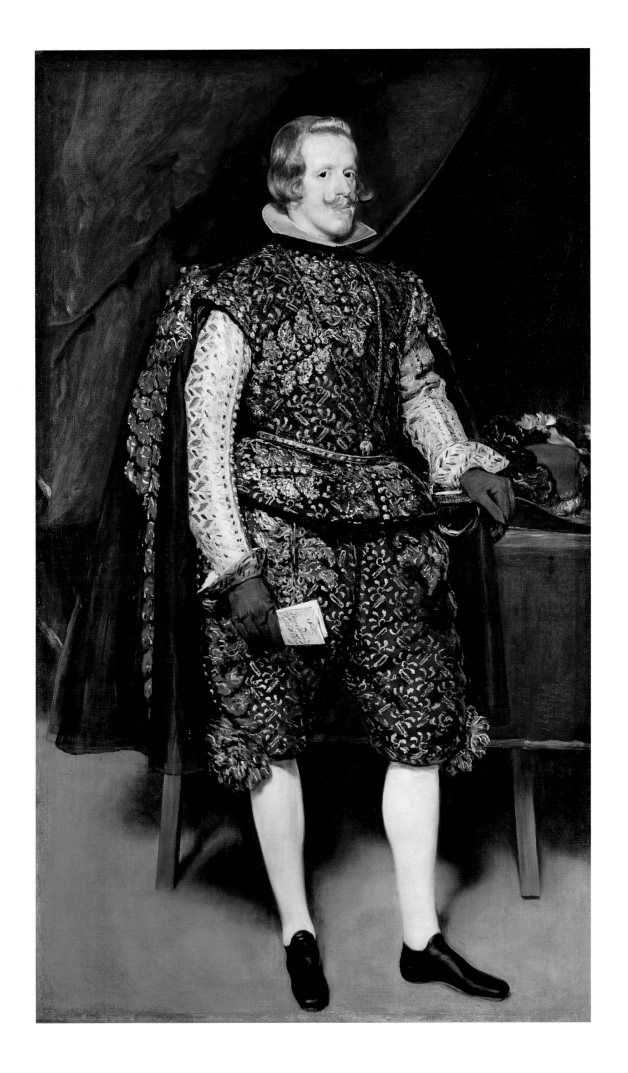

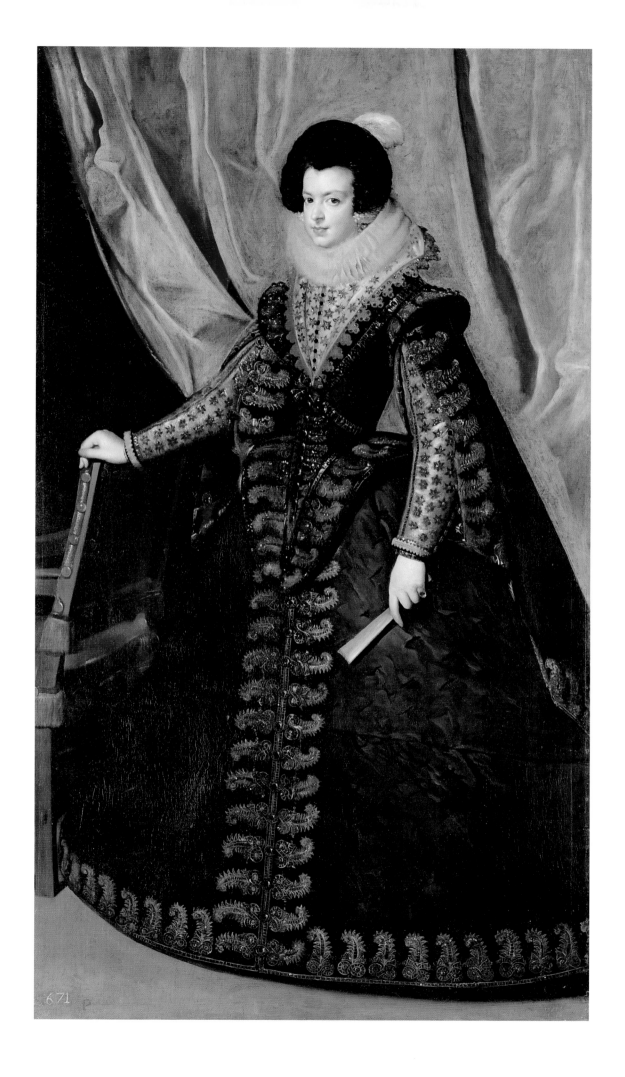

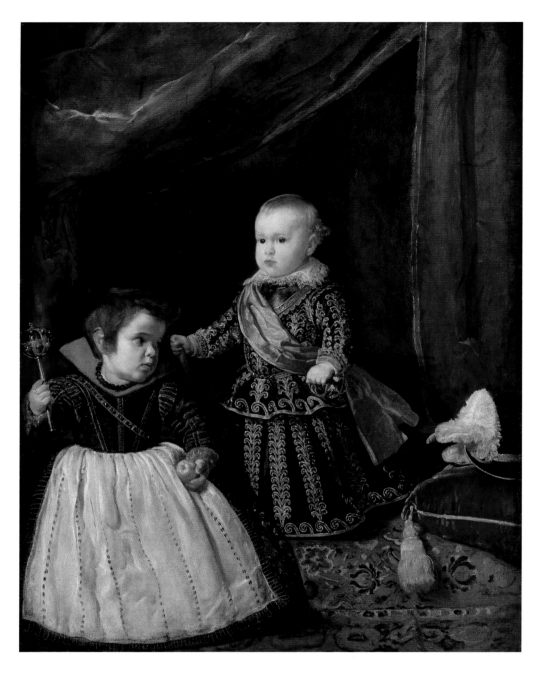

PAGES 32 AND 33:
Philip IV in Brown and Silver, 1631/32
Oil on canvas, 199.5 x 113 cm
London, The Trustees of the National Gallery

The king is holding in his right hand a paper
with the inscription "Señor/Diego Velázquez/
Pintor de V. Mg" – the opening words of a
petition to him from Velázquez.

Queen Isabel, Standing, 1631/32
Oil on canvas, 207 x 119 cm
New York, private collection

Velázquez painted this portrait over an older
picture of the queen that he had executed to-
wards the end of the 1620s.

visit to Italy, although no direct model for it can be identified. None of his
pupils ever matched him in the depiction of such phenomena.

There can be no doubt that the presence of Rubens at court and the
example of his portraits greatly encouraged a more modern and magnifi-
cent style of representation. The building on the outskirts of Madrid of the
castle of Buen Retiro, which the Count of Olivares was anxious to have
lavishly furnished, may be seen as expressing this new demand for splend-
our, for ceremony of a luxurious and artistically refined nature. However, it
would be wrong to see Velázquez as portraying courtly superficiality, self-
satisfaction and an addiction to magnificence. He is fully aware, of course,
of the social rank of his sitters; he knows the rules of etiquette, which no
one, least of all a court painter, may break. He knows that it is his duty to
employ his artistic genius in contributing to the European reputation of the
Spanish court.

But over and above such considerations – and it is here that his end-
uring achievement lies – amidst all the magnificence he takes note of his

ABOVE AND DETAIL PAGE 35:
Prince Baltasar Carlos with a Dwarf, 1631
Oil on canvas, 128.1 x 102 cm
Boston, Museum of Fine Arts, Henri Lillie
Pierce Foundation

The prince's face is modelled with gentle
regularity, whereas the paint is applied to the
head of the female dwarf with more irregular
granulation. This contrasting brushwork is of-
ten used by Velázquez in his pictures to accen-
tuate certain features of their content.

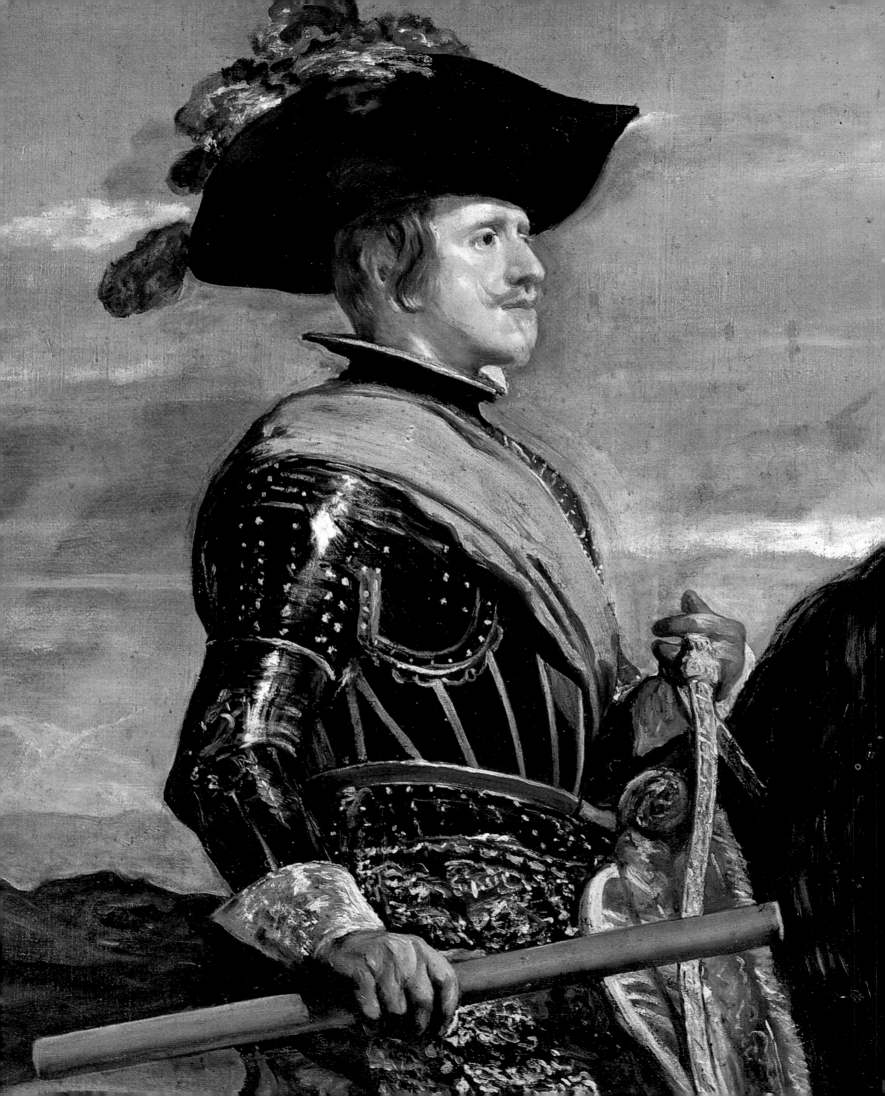

A White Horse, c. 1634/35
Oil on canvas, 310 x 245 cm
Madrid, Patrimonio Nacional, Palacio Real

Philip IV on Horseback, 1634/35
Oil on canvas, 303.5 x 317.5 cm
Madrid, Museo del Prado

PAGE 36:
Detail from *Philip IV on Horseback*, 1634/35

sitters' personalities. He makes statements without passing moral judgements, certainly without condemning. He shows faces that have, so to speak, become transparent to him through their destinies; he shows the over-refined hands of a society of aristocrats revealing itself to the gaze as if it had wearied in the course of the centuries. The subtle beauty and nobility of these princely portraits is so extraordinary that no later artist was ever able to repeat it.

The long-awaited heir to the throne, Prince Baltasar Carlos, born on 17 October 1629, was his parents' pride and joy. While Velázquez was in Rome he attended one of the glittering parties held in many European cities to celebrate the child's birth. No sooner was he back in Madrid than he was commissioned to paint the prince, now sixteen months old, and in another portrait of the same subject he shows the fair-haired little boy with a curious playmate (p. 34). Dressed in a magnificently embroidered ceremonial robe (p. 35) which makes him into a miniature adult, the prince is standing on a carpeted step beneath a draped wine-red curtain, holding a bâton and a

Philip III on Horseback, c. 1634/35
Oil on canvas, 305 x 320 cm
Madrid, Museo del Prado

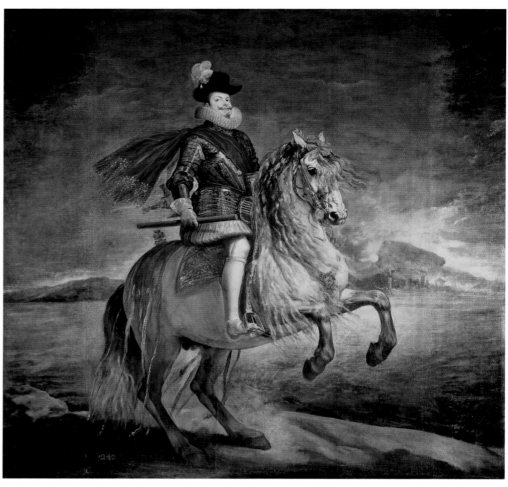

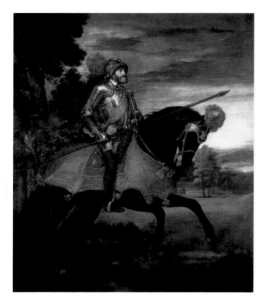

Titian
Charles V at Mühlberg, 1548
Oil on canvas, 332 x 279 cm
Madrid, Museo del Prado

After his appointment as court painter
Velázquez had the opportunity of studying
Titian's famous portrait of the emperor in the
Alcázar. It shows Charles V in military cloth-
ing, but makes no allegorical allusions, and
even dispenses with the depiction of troops
or battle scenes.

dagger in his little hands. The steel gorget indicates his future rôle as a
military commander. His face, expressing all the charm of his French
mother in childish miniature, is turned towards another child in the left
foreground of the picture, and the child's abnormally large head is looking
back at him.

This figure is a dwarf, it is now thought probably a girl, one of the hu-
man toys so popular at many European courts of the time. The physically
handicapped figure of the dwarf holds a silver rattle and an apple in imita-
tion of an orb and sceptre, and is acting the part of a comic major-domo to
the future little king. One wonders whether their Majesties and the courtiers
laughed at this picture and the court painter's amusing idea.

In Spain (and other countries too) there was a long tradition of in-
cluding dwarfs in royal portraits as subordinate figures. Basically, these
deformed little creatures were merely attributes of the royal dignity, part of
the furnishings of the court and regarded as neuter beings rather than fully
human. Velázquez accepts this distinction, yet ultimately he cancels it out.
The little prince is the focal point of the composition of the picture, and the
pigmentation also makes him its brilliant centre, an effect emphasized by
the gold braid on the dark material of his dress and the carmine red of the
sash.

These strongly resonant tones contrast with the more muted colouring
of the dwarf's dark green dress, just as the delicate, light and regular
colouring of the prince's face contrasts with the face of the dwarf girl,
which has more effects of shadow and is treated with greater artistic free-

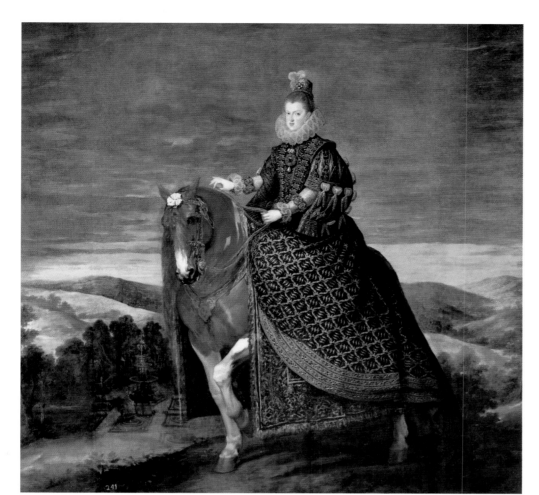

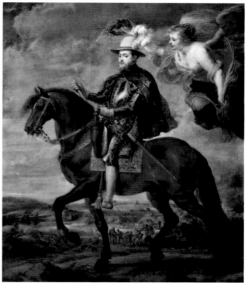

Queen Margarita on Horseback, 1634/35
Oil on canvas, 302 x 311.5 cm
Madrid, Museo del Prado

Peter Paul Rubens
Philip II on Horseback, 1628
Oil on canvas, 314 x 228 cm
Madrid, Museo del Prado

dom. As a result, the prince appears as the very incarnation of the blood royal, the nobler of the two beings presented to our gaze, while the dwarf, with her tousled dark blonde hair, is a subordinate and more animal creature. Yet Velázquez seems to wish to show a more vital human nature in the dwarf's face than in the countenance of the prince, which is already dominated by the duties of his calling; the melancholy inherent in the picturesque shadows says more about the dwarf girl's destiny than the bright flesh tints of Baltasar Carlos's face can tell us about his radiant, princely figure.

The phenomenal skill and impressively subtle psychology of this painting is based on a wealth of nuances that can hardly be described verbally: it is an interplay of harmonies and contrasts, presenting effects of closeness and distance, of the sublime and the human – and indeed of the endearingly childish. Velázquez expresses all this not through complex allegorical allusions but solely in a form where every detail has its meaning, in the magnificence of colour that lends life to the whole, and in a composition of inspired calm and dignity.

In 1630, at the instigation of the powerful prime minister Olivares, building began on a new palace called Buen Retiro on the outskirts of Madrid. It was to be a place where Philip and his court could stay in surroundings more pleasant than those of the old Alcázar. The decoration of the Great Hall, the Salón de Reinos (Hall of the Kingdoms), was completed five years later. Most of the paintings that ornamented the hall at the time are now in the Prado. There are no extant pictures or drawings of what

must once have been its overwhelmingly effective interior design, but a poem by Manuel de Gallegos entitled *Silva topográphica*, published in 1637, describes the way in which the pictures were originally hung. A series of equestrian portraits formed the brilliant focal point of an exhibition of the glories of the Spanish monarchy.

Philip IV on Horseback (pp. 36, 37), painted around 1635, was of course the most important item in this cycle. The king is shown here in all his absolute might and power enjoying, as a contemporary account puts it, a triumph such as few heroes of the past or present could boast. Seventeenth-century Spanish horses, bred from crosses with Arab stallions, were famous for their proud bearing and temperamental beauty. Velázquez had the opportunity of observing them daily in the royal stables (cf. p. 37) or when the king put them through their paces. The curvet represented the peak of equestrian skill, the moment when the rider had to gather all his strength together, and in this picture the king is making his mount curvet. Baroque art also understood this pose as signifying the sovereignty with which a monarch tamed the unruly power of the people or the animal savagery of an enemy.

In line with these ideas, and in a picture now lost, Rubens had already shown Philip IV on horseback triumphing over his enemies. Velázquez does not call upon the emotionally highly charged background usual in Rubens, nor does he employ any grand allegorical accessories. He also does not exaggerate the king's size by placing him in front of a very low horizon with tiny soldiers in the middle ground, as the Flemish master did in his portrait of Philip II (p. 39). While Velázquez uses a more restrained pictorial rhetoric than Rubens, his royal horseman is livelier and more elegant than the subject in another famous painting – Titian's *Charles V. at Mühlberg* (p. 38). The pure profile emphasizes the fine outline of man and beast, and contrasts the rising movement of the horse with the falling slope of an extensive and idealized landscape. Its pigmentation, shot with beautiful shades of green and blue, is reminiscent of sixteenth-century Flemish landscapes.

Philip IV's parents were also depicted in equestrian portraits hung in the Salón de Reinos. However, the picture of *Philip III on Horseback* (p. 38) is by an unknown painter, and was merely over-painted by either Velázquez or an assistant between 1634 and 1635. It is the horse's head in particular that betrays the master's hand. Art historians also assume that later corrections were also made by the court painter and one of his workshop assistants to the portrait of Philip's mother, *Queen Margarita on Horseback* (p. 39).

While even Philip IV's wife Isabel was represented in the Salón only by another retouched equestrian picture (1634/35; Madrid, Museo del Prado), the painting of *Prince Baltasar Carlos on Horseback* (p. 28) is once again entirely by Velázquez' own hand. Highlights applied with masterly skill emphasize the flowing contours around the prince's face, which is bathed in light and appears translucent, as if in a pastel. Even the shadows cast by the brim of his hat are transparent. The gold embroidery of the Infante's green costume stands out in attractive contrast, emphasizing the brilliant blond of the child's hair.

Velázquez' most impressive equestrian portrait, however, painted in 1634, did not depict any member of the royal family but took as its subject

Count-Duke of Olivares on Horseback, 1634
Oil on canvas, 314 x 240 cm
Madrid, Museo del Prado

The bottom left corner of the picture shows an unfolded empty sheet of white paper. Curiously, although he usually failed to sign and date his paintings, Velázquez often added such blank pieces of paper to his pictures but wrote nothing on them.

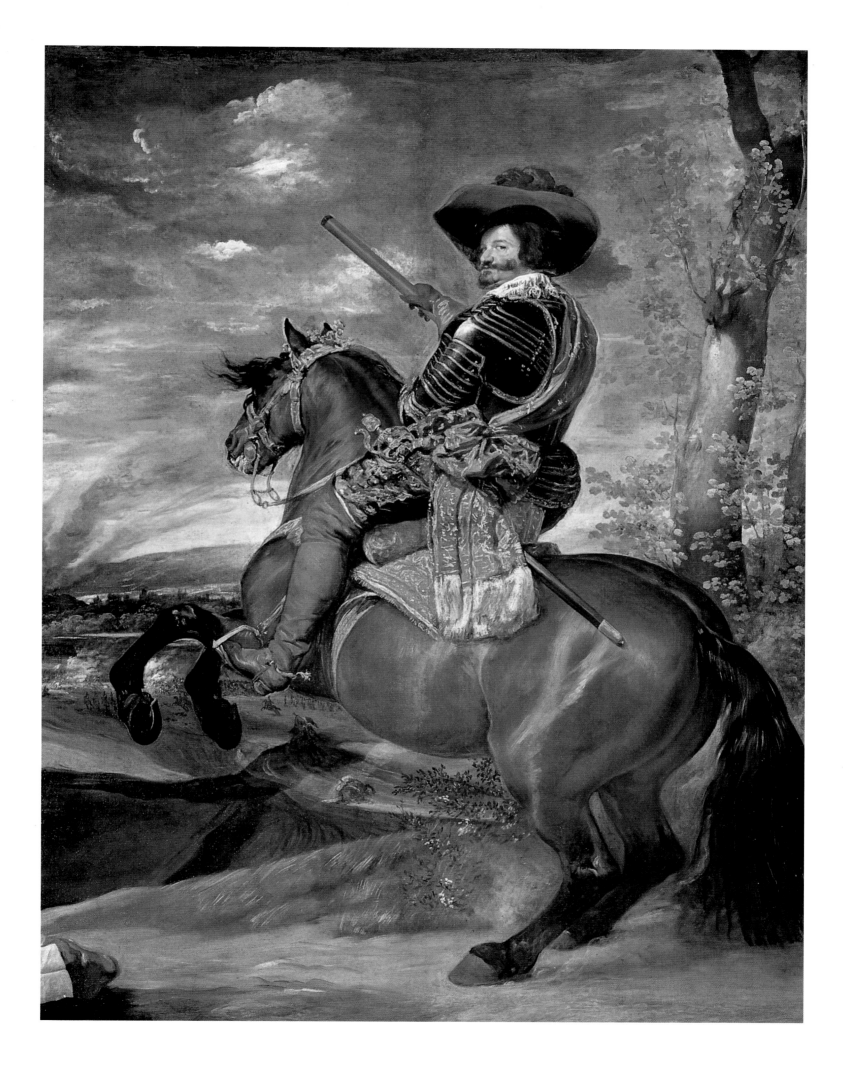

Count-Duke of Olivares on Horseback (p. 41). At that point in time, Olivares, by now the most powerful man in the kingdom, sometimes even more powerful than the king, could describe himself by the title of Count-Duke. He expressed his sense of his own dignity by having himself painted on horseback, an honour usually accorded only to ruling heads of state, and Velázquez constructed a Baroque equestrian portrait of extremely bold composition.

Olivares, famous for his horsemanship, is shown as a field-marshal with a plumed hat, a cuirass adorned with gold and a bâton; seated on his mount, he is leaping down from a height into the depths below, and his figure fills the entire breadth of the canvas. The viewer looks diagonally upwards at the horseman, whose head is turned well to one side, so that he himself is looking down on the viewer from above in a lordly manner. The magnificent chestnut horse has its head turned the other way and is looking down into the depths of the picture, where the smoke of fires and gunpowder rises on a wide plain, and the turmoil of battle is show raging in miniature. Despite theories that have often been put forward, this picture does not necessarily show any particular battle; instead, it alludes in general to the military skill of the man who led the king's armies from triumph to triumph.

No sooner was Buen Retiro completed than Philip IV began on his next project. It was already quite usual for the king to ride out with a small retinue in the extensive game preserves of the densely wooded Pardo – Philip was a bold and enthusiastic huntsman, and he wanted his court painter to record the stags he had killed for posterity (p. 43). Emperor Charles V had built a watchtower on the way to the mountainous hunting grounds of the Sierra, as a place to stop and rest before the most strenuous stage of the journey. This tower was known as the Torre de la Parada, and Philip, who was particularly fond of it, extended it to make a comfortable hunting lodge. He was in haste to see it furnished, and commissioned Rubens to provide a large collection of new pictures on mythological subjects.

After 1638, when the building itself was completed, it was the task of Velázquez to decide how they should be hung, and to contribute a series of hunting portraits himself, to hang with other appropriate works already in existence and with pictures by Dutch masters. This project cost him a great deal of time and trouble, but it also won him increasing appreciation at court.

The three extant hunting portraits by Velázquez are life-size. The portrait of the king (*Philip IV as a Hunter*; ill. left) was painted around 1632/33, and was altered a number of times. The royal model stands in a relaxed attitude in front of a dark oak tree, with a well-trained mastiff at his feet. A broad, light-coloured landscape stretches out before him. He is dressed for stalking in a brownish-green weatherproof tunic, leather gaiters and yellow gauntlets. This portrait shows the private man at ease rather than a splendid official figure – yet such is the skill of the painting that we are still aware of the subject's royal dignity.

A companion piece painted several years later shows Crown Prince Baltasar Carlos in hunting costume (p. 44), "when he was six years old", according to the inscription, which would make the date 1635, or more probably 1636. While the king's portrait conveys the atmosphere of late

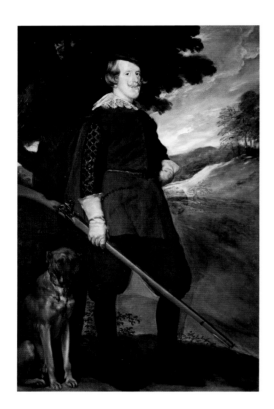

Philip IV as a Hunter, c. 1632/33
Oil on canvas, 189 x 124.2 cm
Madrid, Museo del Prado

PAGE 43:
Head of a Stag, 1626/27
Oil on canvas, 66.5 x 52.5 cm
Madrid, Museo del Prado

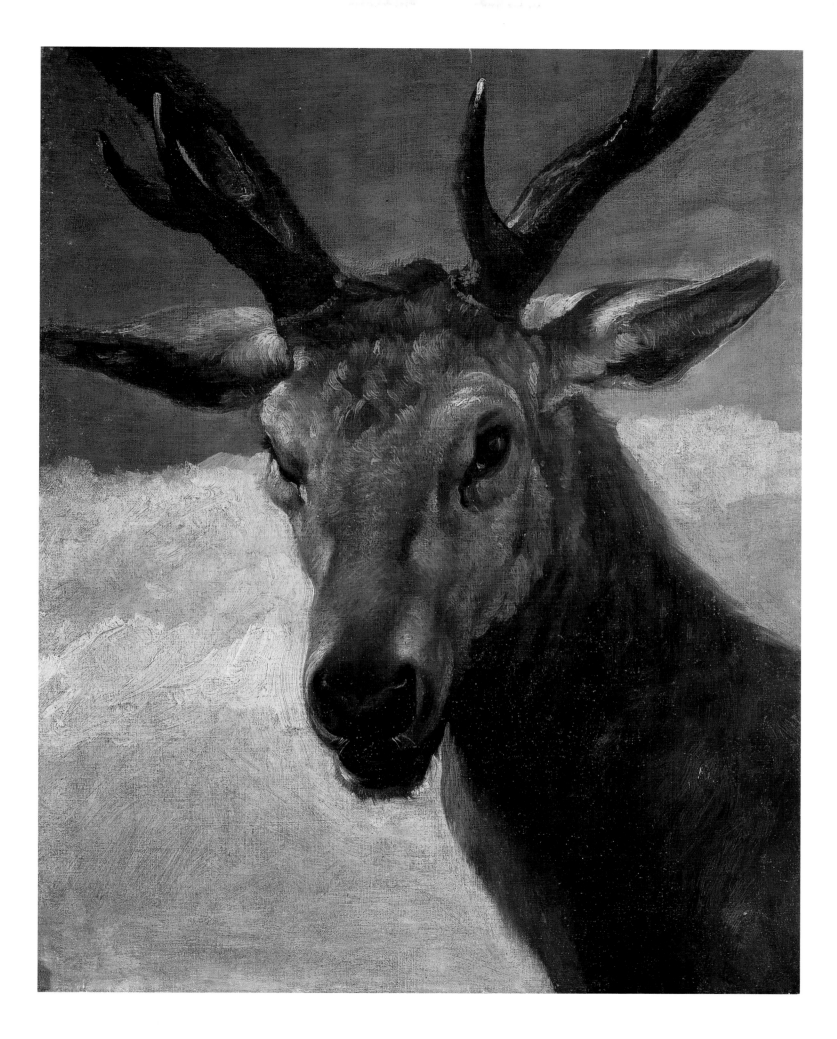

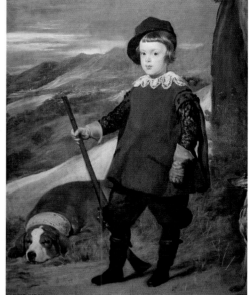

Prince Baltasar Carlos as a Hunter, 1635/36
Oil on canvas, 191 x 102.3 cm
Madrid, Museo del Prado

afternoon in hot weather, the picture of the prince seems to reflect a cool
morning: the grass, wet with dew, is still shimmering in shades of blue-
green in front of the dozing setter.

The hunting portrait of the Cardinal Infante Don Fernando (p. 45) was
also painted to be hung in the Torre de la Parada. Velázquez completed it
around 1632/33. Despite his spiritual calling, the king's younger brother did
not hesitate to indulge his passion for hunting. In this painting, showing
him with his gun at the ready, he looks even more of a huntsman than his
relations. His expressive outline balances the silhouette of the cinnamon-
coloured dog sitting in front of him, a figure once again illustrating the
court painter's skill in depicting animals. He pays them as much careful
attention as he expends on human beings; while he is of course aware of
the differences between animals and humans, he is also conscious of the
dignity shared by all living creatures. The natural elegance of a horse's
head or the body of a dog, their fiery or faithful natures – few painters have
captured the beauty and individuality of animals as unforgettably as
Velázquez.

PAGE 45:
*The Cardinal Infante Don Fernando as
a Hunter*, c. 1632/33
Oil on canvas, 191.5 x 107.8 cm
Madrid, Museo del Prado

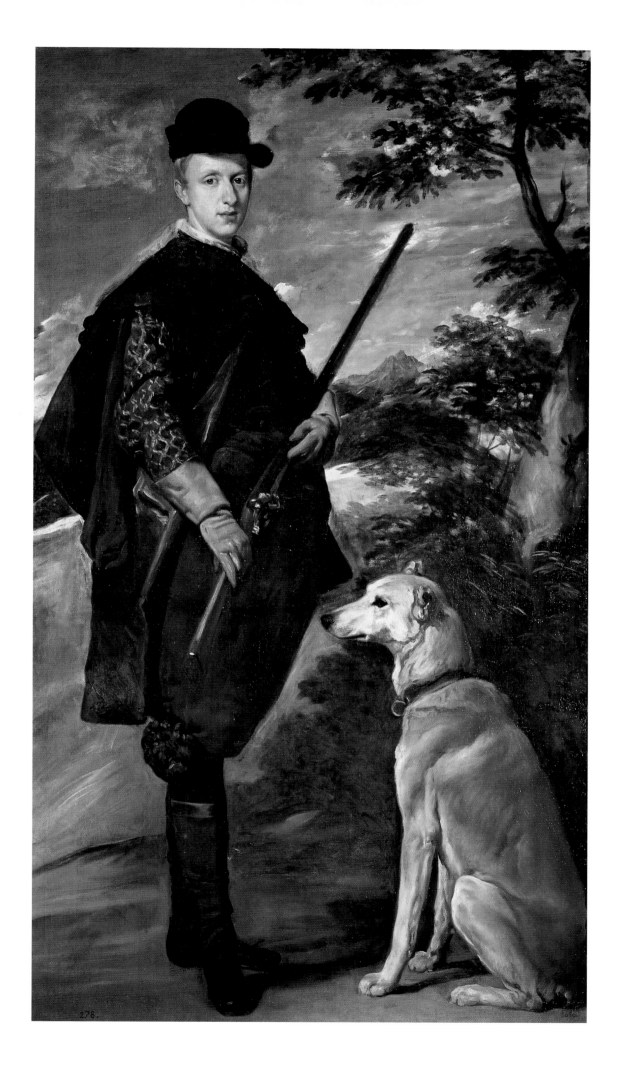

A Humane Equilibrium

In the Salón de Reinos, the throne-room of Buen Retiro where courtly ceremony was displayed to the full, symbolically representing the monarchy to the outside world, a series of ten pictures by Zurbarán on the theme of Hercules hung beside the equestrian portraits of members of the Spanish ruling house of Habsburg. There were also twelve battle scenes showing the latest victories won under Philip IV. All the military paintings follow the same standard pattern: they banish war itself to the background and show the victorious commanders full-length in the foreground, where the figures of rulers are usually placed in other works.

The battle pieces may well have been painted by Velázquez' artistic colleagues Eugenio Caxés (1573/74–1634) and Vicente Carducho, or by Zurbarán. They are not particularly original, unlike the paintings by Fray Juan Bautusta Maino and (as one might expect) by Velázquez himself. Maino's painting was taken from the subject of a play by Lope de Vega celebrating the recapture of Bahía in Brazil by the Portuguese and Castilians after its occupation by the Dutch. However, the main theme of the picture is not so much the battle as the noble magnanimity of the victors and their care for the wounded.

In *The Surrender of Breda*, painted in 1634 to 1635 (pp. 48/49), Velázquez too makes a fundamental statement about humane conduct amidst the horrors of war. Many contemporary witnesses felt sure that the long struggle for the Netherlands would determine the future position of Spain as a world power. The most important fortress in the southern Netherlands was Breda in Brabant, and the strategic significance of the place was correctly assessed by Philip IV's best commander in the Thirty Years' War, Ambrosio Spinola, a rich Genoese nobleman who had been awarded the Order of the Golden Fleece. The commander of the fortress on the opposite side, Justinus of Nassau, was another military man famous throughout Europe. After a four-month siege and when all the provisions in the fortress had run out, he was forced to petition for an honourable surrender. Spinola allowed him to leave under conditions that were extremely generous for the period.

The official surrender took place on 5 June 1625. The conquered army was permitted to leave the city with dignity, carrying its colours and its weapons. Spinola was waiting on horseback at the city gate with a few noblemen, and magnanimously saluted the Dutch general as he came first out of the fortress, followed by his wife riding in a carriage.

Spanish Soldier, detail from *The Surrender of Breda*, 1634/35

PAGE 46:
Dutch Soldier, detail from *The Surrender of Breda*, 1634/35

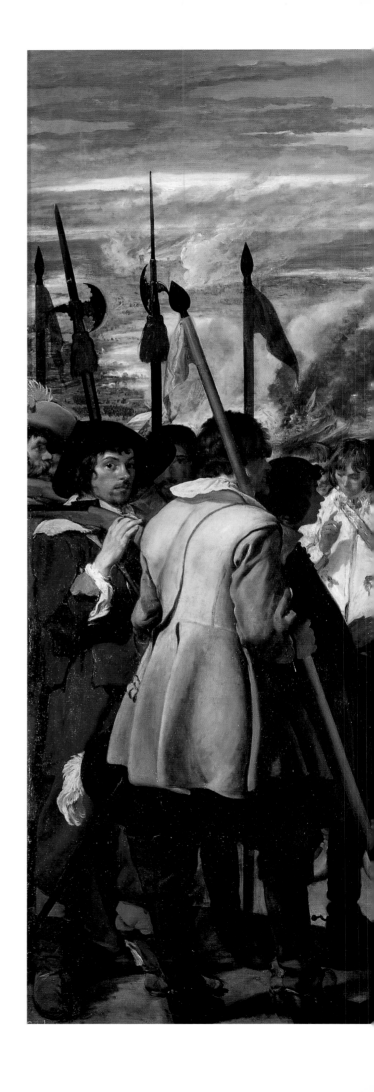

The Surrender of Breda (Las Lanzas),
1634/35
Oil on canvas, 307.5 x 370.5 cm
Madrid, Museo del Prado

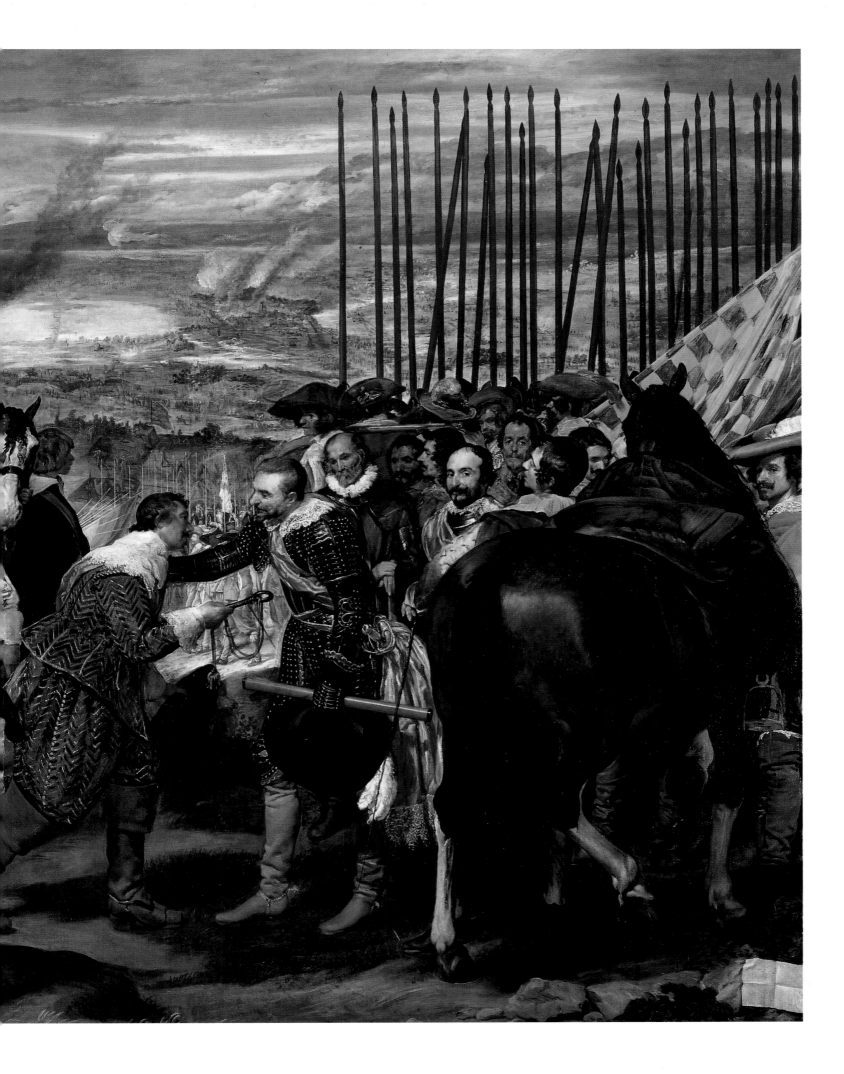

PAGE 51:
Detail from *The Surrender of Breda (Las Lanzas)*, 1634/35

Velázquez met Spinola himself during his first visit to Italy. In the picture he emphasizes the commander's nobility and humanity. Spinola is chivalrously receiving his defeated opponent Justinus of Nassau, laying a hand on his shoulder in recognition of his enemy's feats, and apparently ignoring the humiliating act of the surrender of the key.

Don Pedro de Barberana, detail from *The Surrender of Breda*, 1634/35

Don Pedro de Barberana y Aparregui (detail), 1631/32
Oil on canvas, 198.1 x 111.4 cm
Fort Worth, Kimbell Art Museum

News of the victory was greeted with relief and delight in Madrid, and by Pope Urban VIII in Rome. The Pope congratulated Spinola on washing his hands in the blood of the heretics. A play by Calderón de la Barca on the subject of the siege of Breda was performed in Madrid in November 1625. The dramatist makes Spinola say of his adversary, in a proud yet modest phrase that has become proverbial, "The valour of the conquered makes the conqueror famous". The young Velázquez probably saw the production of this play at court. Now, nine years later and after making many drawings as preparatory studies, he was to paint a historical picture on the subject. During his work he kept casting a critical eye on the events shown on his canvas, correcting and painting over them, yet the final result conveys a sense of great ease. Velázquez had painted one of the most famous and accomplished war pictures in the history of art – and it is surely the most deeply moving in human terms.

An impressive and dramatic scene of war unfolds on the huge canvas. The viewer has an aerial view of the now silent battlefield in the distance; smoke rises from fires beneath clouds and blue-grey mists. We look across trenches, water-works and blockhouses; only Breda itself is absent from the picture. The brightly lit background, bathed in shades of pale blue and pink, suggests the landscape backgrounds of Tintoretto. The Dutch are coming up from the depths of the picture, passing from right to left through the double line of upright Spanish spears. Velázquez makes this dense forest of spears pointing to the sky so dominant a feature of the picture as a whole that it has given the painting its sub-title of *Las Lanzas*.

By now the protagonists have assembled on the rising ground in front, which is the main scene of the action and on the viewer's eye-level. There are nine figures on each side: the Dutch to the left, the Spanish to the right. The group on the left opens up and the Dutch commander steps forward, his glance sad and weary, sketching a bow as he hands over the key of the city (p. 51). With delicacy of feeling, Spinola bends down to him and lays his mailed hand on his enemy's shoulder with a courteous smile – a sympathetic and a noble gesture. Behind him, a groom forces a magnificent nervously prancing horse to one side.

The group of defeated men is constructed more loosely and with more variety of lighting and colour than the well-disciplined company of victors: the Dutch are weather-beaten soldiers like the musketeer on the left of the picture (p. 46); the Spanish are more elegant and sophisticated. The wall of spears, the weapons of the undefeated *tercios*, the famous Spanish infantry, emphasizes their still menacing power, at the same time lending the military commander's humanity and merciful conduct its full weight and providing a foil for it.

The bearing and appearance of the soldiers display Velázquez' inexhaustibly rich orchestration of their feelings and their states of mind. In some of the faces he has taken his inspiration from types of his own invention, for instance the figures in the *Forge of Vulcan* (p. 23). The officer with chestnut-brown hair to the right behind Spinola represents Don Pedro de Barberana, a knight of the Order of Calatrava, whom the court painter had already portrayed in 1631/32 (ill. left). The vibrant application of paint, the painter's extraordinary understanding of the way in which light and the atmosphere can change colours, the symphony of brilliant and muted tones that fills the picture, making it sparkle and glow with joyful harmonies, the

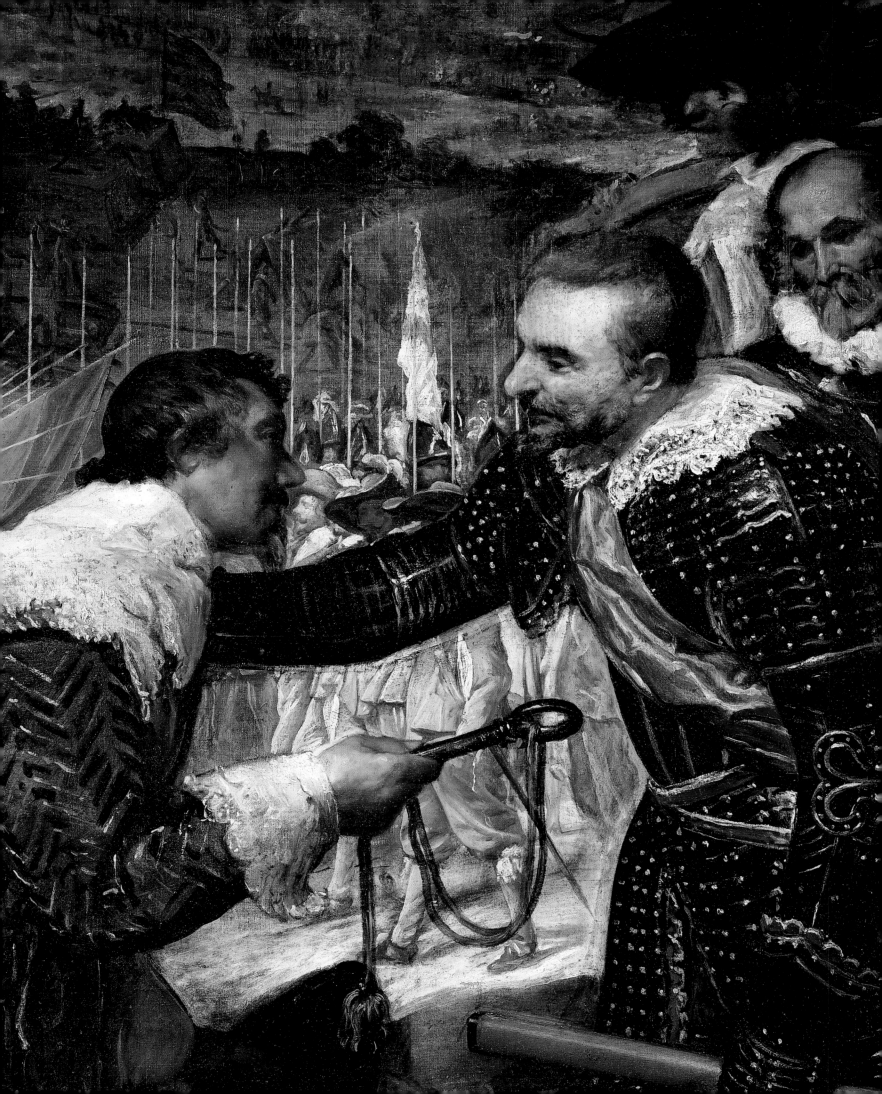

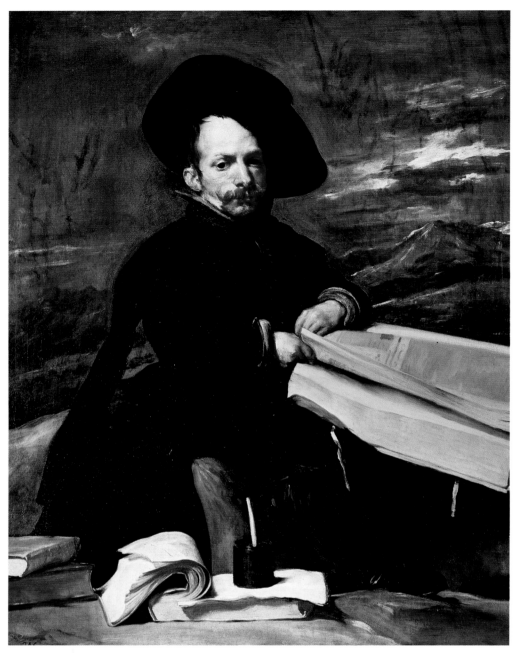

A Dwarf Holding a Tome on his Lap (Don Diego de Acedo, el Primo), c. 1645
Oil on canvas, 106 x 83 cm
Madrid, Museo del Prado

Dwarf, detail from *Prince Baltasar Carlos with the Count-Duke of Olivares at the Royal Mews*, c. 1636

manner in which the composition concentrates dramatically on the surrender of the key while the formal rhythms of victory and defeat unfold, all mark a crucial watershed in the art of Velázquez.

The *Surrender of Breda*, which contains no allegorical or mythological references, is indisputably the first purely historical picture in modern European painting, and among the outstanding works of world art. In another manner, and one that is always striking and sometimes curiously moving to modern observers, Velázquez shows human nature in all its diversity when he presents the gallery of dwarfs and jesters who lived at court and whose task it was to preserve the king from boredom in the midst of routine etiquette.

Under cover of joking, the court jesters or buffoons, in Spanish *truhanes*, would often tell their lords and masters the home truths openly discussed by the ordinary people. They could move freely in the king's presence, trying to amuse the naturally melancholic Philip IV with their

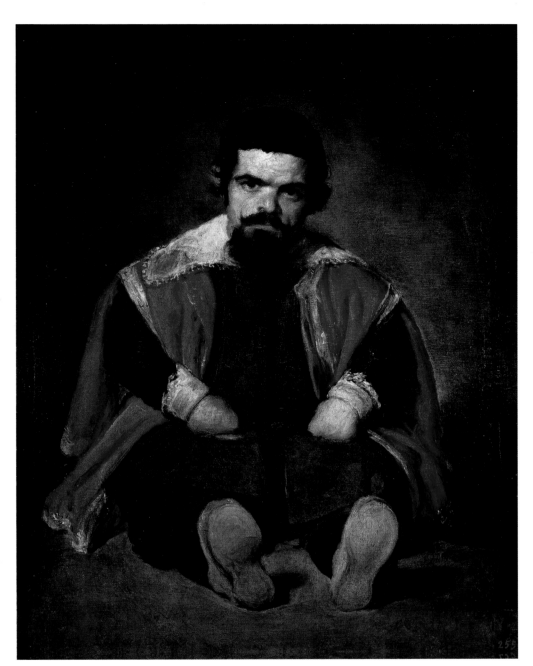

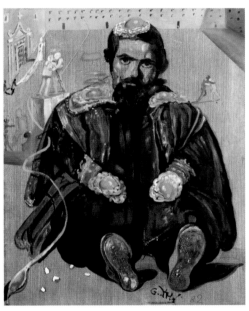

A Dwarf Sitting on the Floor (Don Sebastián de Morra?), c. 1645
Oil on canvas, 106.5 x 81.8 cm
Madrid, Museo del Prado

This painting, a copy of which by Velázquez is also extant, originally hung in the Alcázar in Madrid. Today the picture has been considerably cut down, particularly at the right-hand border.

Savador Dalí
Velázquez Dying behind the Window on the Left Side out of which a Spoon Projects, 1982
Oil on canvas with collages, 75 x 59.5 cm
Figueras, Teatro-Museo Salvador Dalí

caustic remarks. To judge by their salaries, their position in society was quite high. Velázquez himself, on entering the service of the palace as a court painter, had at first been classed with the royal servants, and as a result shared the life of these *truhanes*. The dwarfs who acted as living toys – and sometimes as whipping boys for the young princes and princesses – were regarded differently. The hidalgos and ladies of the time, who enjoyed normal stature, probably felt particularly privileged both in mind and body by comparison with the stunted growth and wizened faces of the dwarfs.

Finally, and in the lowest social category, came those freaks of nature, the harmlessly deranged, constituting a kind of human menagerie. With his brilliant powers of observation and his psychological sensitivity, Velázquez recorded every detail of the physical abnormalities and confused minds of this curious class of society, with perfect honesty, but never mocking or caricaturing them, never depicting them with perverse pleasure, or indeed with feigned or sentimental pity. On the contrary, we sense a stoically calm

PAGES 54 AND 55:
The Buffoon Calabazas (Calabacillas),
1637–1639
Oil on canvas, 106.5 x 82.5 cm
Madrid, Museo del Prado

*The Dwarf Francisco Lezcano
(El Niño de Vallecas)*, c. 1643–1645
Oil on canvas, 107.4 x 83.4 cm
Madrid, Museo del Prado

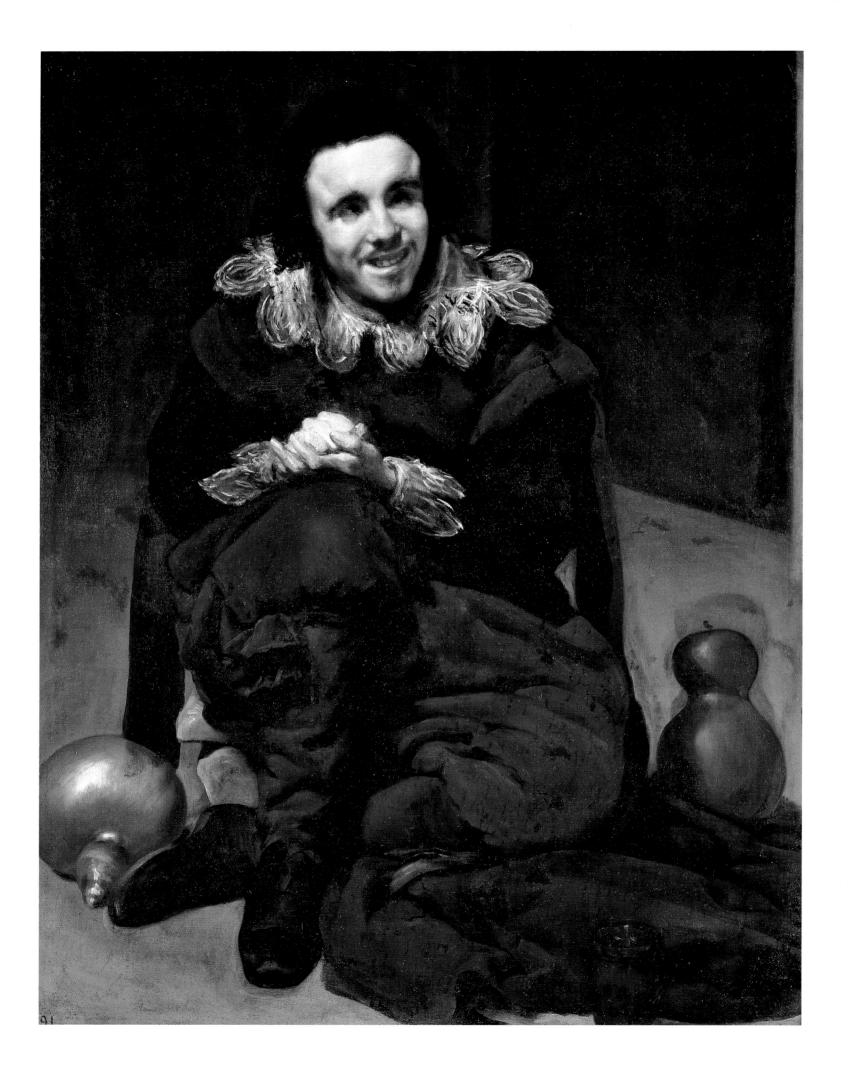

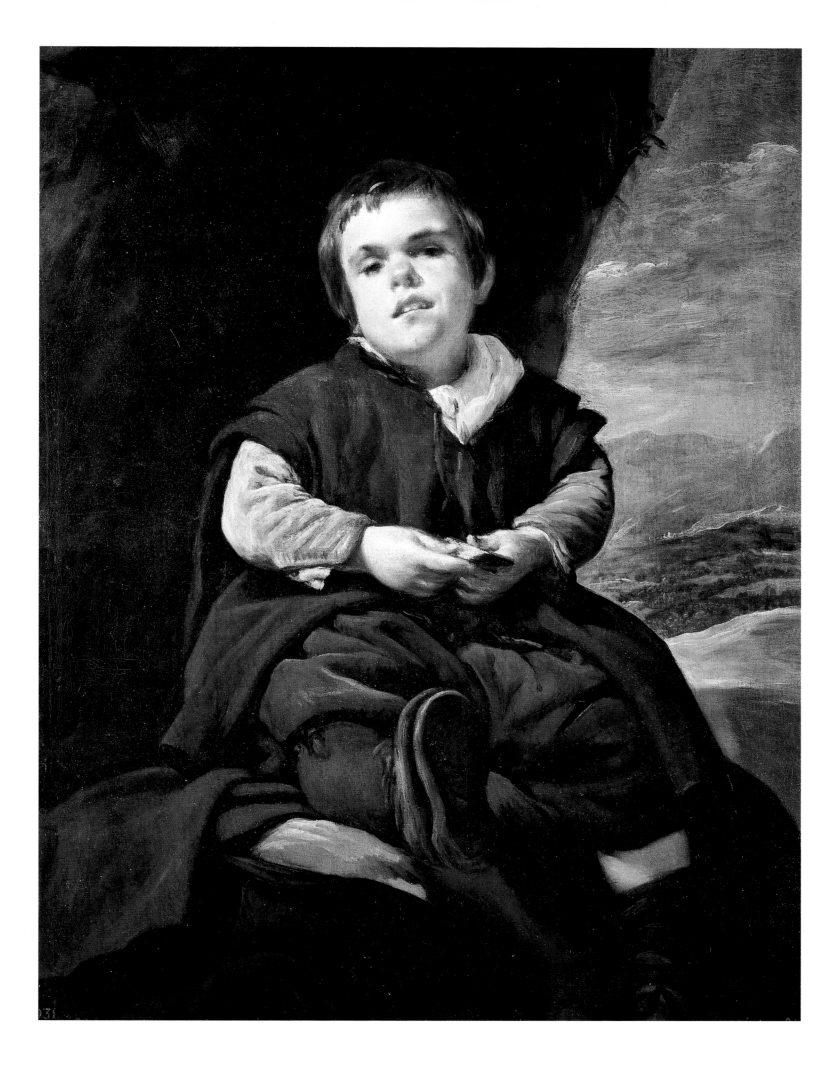

humanity in his attitude to these sitters – and we recognize a greatness of mind that was in no way inferior to his artistic genius.

The first portrait Velázquez painted in 1628/29 of a court jester was that of Juan Calabazas or Calabacillas. Ten years later, around 1637–1639, he painted him again (p. 54). All the firm lines have now gone from the buffoon's face; instead, its surface consists of an extraordinarily subtle texture of colour and shade, while the white lace collar is a fantastic, filmy tissue. The small eyes look out from deep sockets. The motif and the sense of picturesque unreality convey the idea of a strange intermediate world where the court jester perhaps lived his real life.

The Dwarf Francisco Lezcano (p. 55), painted by Velázquez around 1643–1645 as a retarded boy of fifteen, was a burlesque piece that formed part of the decoration of the Torre de la Parada. The feeble-minded dwarf, dressed in green, is lovingly caressing the playing cards he holds. His bloated, over-large features are almost monumental, and a curious beauty plays over the face of the hydrocephalic dwarf.

For his pictures of these fools and dwarfs Velázquez often chose the format of a rectangle coming down close to the head, within which the figures crouch as if in a compact, closely circumscribed world; another example is the portrait of *A Dwarf Holding a Tome on his Lap* (p. 52). This picture, painted around 1645, was also in the Torre de la Parada. We are not sure of the name of the sitter clad in elegant black with an extravagant hat, leafing through a book and appearing to take a great interest in literature. Was he in fact "El Primo", who believed himself, as the nickname indicates, a cousin of Velázquez? Is he the same dwarf as the one shown behind Prince Baltasar Carlos in a painting of c. 1636 (pp. 52 and 60)? His identity remains a matter of controversy and is perhaps of no importance by comparison with the fascinatingly life-like depiction of his figure in front of a strangely eerie background.

The dwarf who, along with El Primo, enjoyed the highest esteem at court was Don Sebastián de Morra. He is probably the subject of *A Dwarf Sitting on the Floor* (p. 53). There are two versions of this portrait, both painted around 1645. The composition is extremely original, and in the twentieth century Salvador Dalí was inspired to produce a surrealistic paraphrase (p. 53). The bearded dwarf is sitting on the floor, wearing green with a short red cloak. His legs are stretched out in front of him, feet pointing upwards in a comical position that shows the viewer the dirty soles of his shoes, and his stumpy arms contrast with his massive torso, making it look almost like a monumental bust. The intense play of light and shade and the deliberately broad application of highlights illustrate the dwarf's irascible character.

Velázquez shows all the deformities of these comical or feeble-minded members of court society – as well as all the individual features deriving from violent emotion, congenital mental handicap and from age. He also painted a masterly picture of *The Buffoon Don Cristóbal de Castañeda y Pernia* (ill. left and p. 57), who was first in rank among the court jesters. He gave himself airs as a great military expert, thus earning the nickname of Barbarroja (Barbarossa or Red-beard). His red robe is almost Turkish in style, and his head-dress suggests a fool's cap. He glares fiercely into space, and while he grips the sheath of his sword firmly, the sword itself is held in a relaxed position.

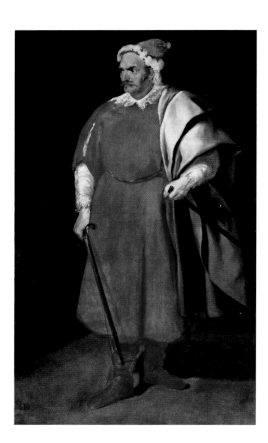

The Buffoon Don Cristóbal de Castañeda y Pernia (Barbarroja), 1637–1640
Oil on canvas, 200 x 121.5 cm
Madrid, Museo del Prado

PAGE 57:
Detail from *The Buffoon Don Cristóbal de Castañeda y Pernia (Barbarroja)*, 1637–1640

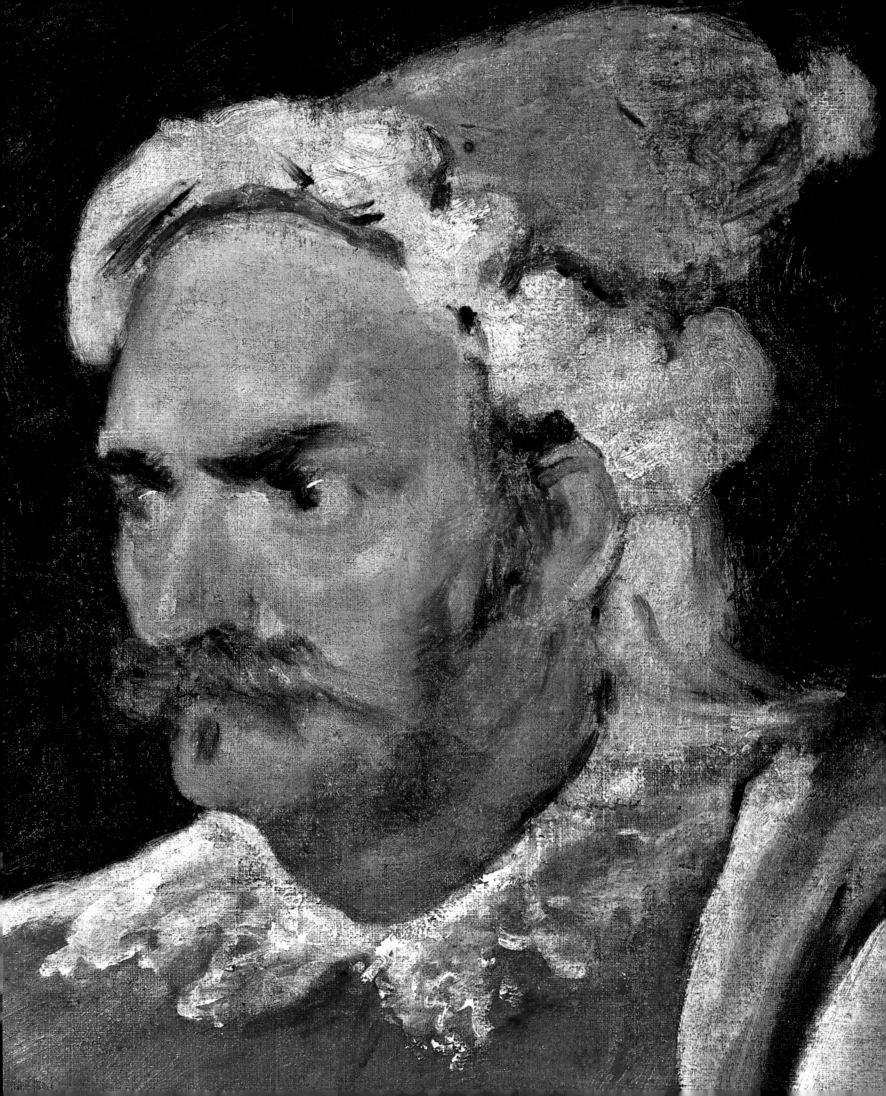

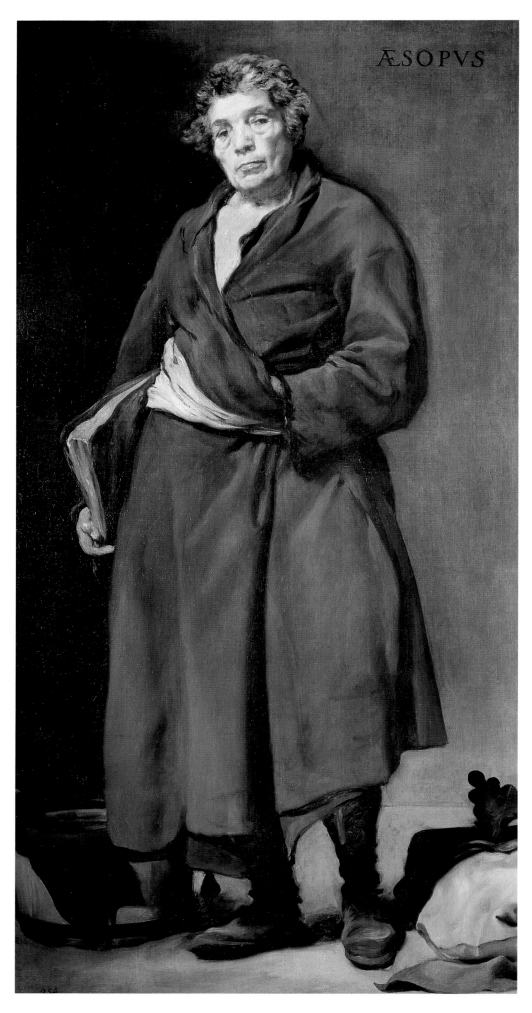

ÆSOPVS

Aesop, c. 1639–1641
Oil on canvas, 179.5 x 94 cm
Madrid, Museo del Prado

The classical author of the famous fables
holds his hand close to his chest, which in the
figurative language of the time may refer to
the character type of the phlegmatic man. The
barrel at Aesop's feet is also an indication
that this type was supposed to have a special
affinity with water.

The Buffoon Pablo de Valladolid, c. 1636/37
Oil on canvas, 213.5 x 125 cm
Madrid, Museo del Prado

The court jester, posing like an actor, stands in a curiously indeterminate space showing no floor-line. Later painters such as Goya and Manet were enthusiastic about this masterpiece, not least for its originally glowing tones of grey in the background, now turned to an unattractive ochre.

RIGHT:
<u>Edouard Manet</u>
The Fifer, 1866
Oil on canvas, 161 x 97 cm
Paris, Musée d'Orsay

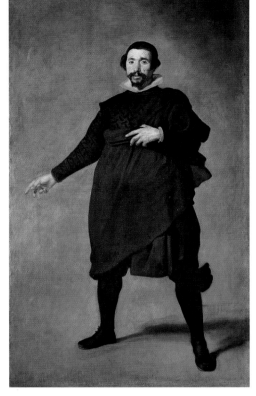

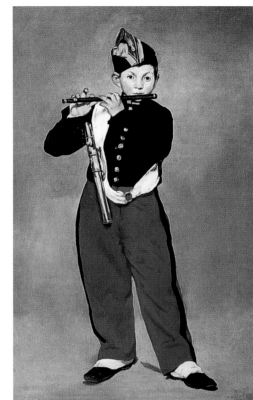

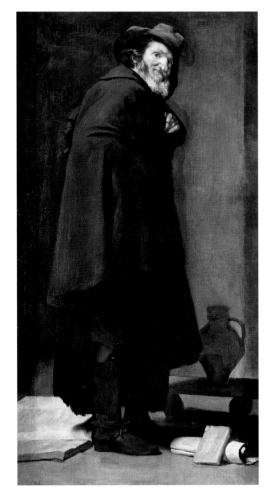

Menippus, 1639–1641
Oil on canvas, 178.5 x 93.2 cm
Madrid, Museo del Prado

Velázquez began this portrait towards the end of the 1630s and left it unfinished; another painter later worked on it, in particular on the grey cloak. Despite their handicaps the dwarfs and jesters depicted by Velázquez are also acute observers of worldly power. The fascinating penetration imparted by the artist to their eyes in particular suggests that, looking out from their own intermediate world, they can see through all the conventions of a society that believes itself superior, and view it more clearly than many a "normal" courtier. The artist's intellectual attitude here helps to explain the similarities between these human outsiders and his pictures of philosophers.

His *Aesop* (p. 58) is now almost unanimously dated to around 1639–1641, and it is thought to have been painted for the Torre de la Parada, with the *Menippus* of the same period (ill. left). Aesop, the classical author who reflected human life in the guise of animal fables, and the philosopher Menippus, a cynic and satirist, are both shown full length and would have made suitable counterparts to the pictures of Democritus and Heraclitus by Rubens in the Torre de la Parada. Velázquez gave Aesop's face the fleshy features of the human "ox-head type" described in the physiognomical doctrines of the Italian Giovanni Battista della Porta, published in 1586, which again calls Aesop's animal fables to mind.

Of greater importance, however, are the eyes: one almost feels that in the landscape of Aesop's face they are all that is left of the grounding of the canvas. They are deep-seated and probing, turned on the observer with a slight touch of contempt. Like the eyes of many of Velázquez' dwarfs and fools, their gaze is full of the irony that sees through convention. Aesop, who lived from about 620 to 560 BC, began life as a slave and died a violent death. In this picture his face, marked by suffering, shows the same simple dignity as that of the court jesters or country folk painted by Velázquez.

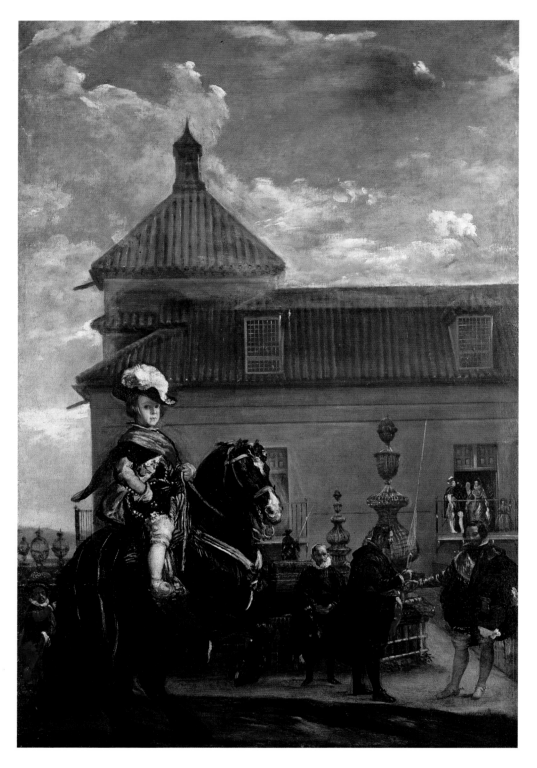

**Prince Baltasar Carlos with the Count-Duke
of Olivares at the Royal Mews**, c. 1636
Oil on canvas, 144 x 96.5 cm
London, His Grace the Duke of Westminster

The belly of the horse on which the little
prince is mounted is disproportionately convex
and in fact so coarsely depicted that one sus-
pects the unskilful hand of an apprentice
rather than a deliberate distortion.

PAGE 61:
Detail from **Prince Baltasar Carlos with the
Count-Duke of Olivares at the Royal Mews**,
c. 1636

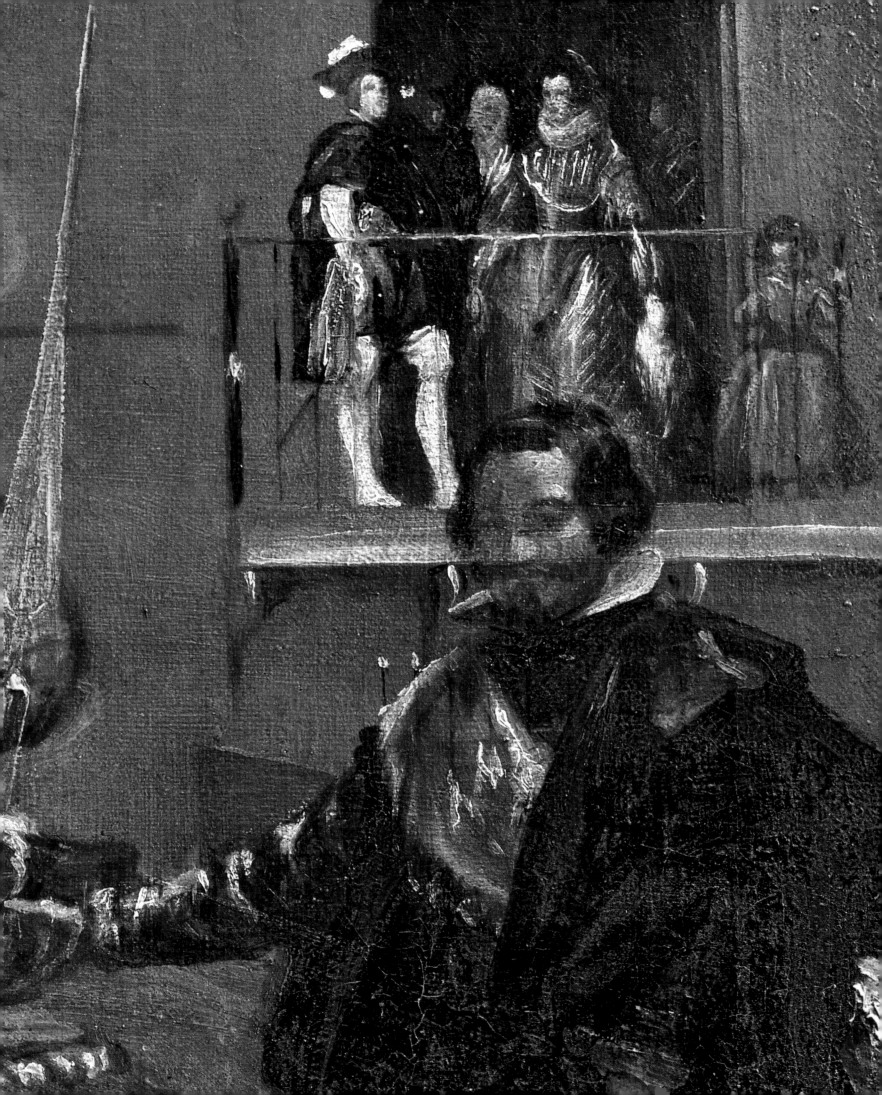

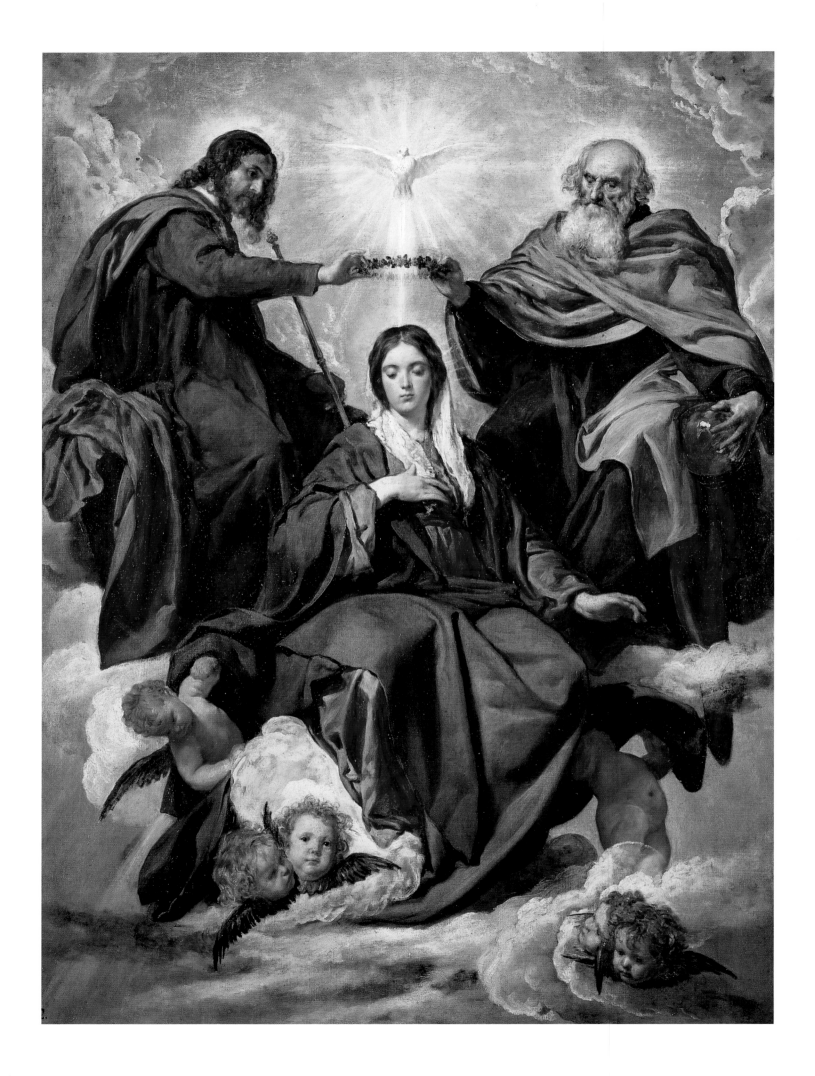

Detail from *The Coronation of the Virgin*, c. 1645

For instance, if one compares the face of *The Buffoon Pablo de Valladolid* (p. 59), painted around 1636/37, with the face of the much earlier *Democritus* (p. 6), it is easy to see similarities suggesting the possible use of the same model. In the nineteenth century, Edouard Manet was inspired to produce a paraphrase of this picture (p. 59) not so much by the jester's intense facial expression as by the strong tension of his outline.

As a court painter, Velázquez was of course required to paint group portraits as well as these actual or fictional portraits of individual figures. He organized a workshop of competent artists, and in 1633 recruited the services of his son-in-law Juan Bautista Martínez del Mazo (1610/15–1667). Mazo probably did a good deal of work on the picture of around 1636 showing *Prince Baltasar Carlos with the Count-Duke of Olivares at the Royal Mews* (p. 60). The Count-Duke stands in the middle ground to the right of the picture, with his master-at-arms; figures on the balcony above him include Philip IV, Queen Isabel and several courtiers who cannot be identified for certain (p. 61).

Another of the tasks required of Velázquez, though to a lesser extent, was the painting of altarpieces. *The Coronation of the Virgin* (p. 62 and ill. above) was painted around 1645, possibly for the queen's oratory in the Alcázar in Madrid. Angelic *putti* carry the virginal Madonna up to heaven on clouds; Christ and God the Father hold a wreath of roses over her head, and the dove of the Holy Ghost hovers above her in an aureole of light. The glory of the coronation of the Mother of God and her perfect features are signs of her virginity.

This picture shows several scenes from the legend of these saints simultaneously. In the background, St. Anthony is asking a centaur the way to the hermit Paul. As he goes on he meets a horned monster with goat's feet, and on the right he is knocking on the door to the cave. The main scene shows the raven bringing the two saints a loaf of bread from heaven. To the left, we see the closing sequence: two lions are digging a grave for St. Paul while St. Anthony prays beside his corpse.

Joachim Patinir
St. Jerome, 1510–1515
Oil on canvas, 74 x 91 cm
Madrid, Museo del Prado

Around ten years earlier the painting of *St. Anthony Abbot and St. Paul the Hermit* (p. 65) had been commissioned, possibly for the Hermitage in the Buen Retiro. Various models have been suggested for this composition, including a woodcut by Albrecht Dürer (1471–1528) for the group of figures. The woodcut also shows the raven flying down to bring the hermits a loaf of bread, in the same attitude as in Velázquez' painting (ill. right). A model for the landscape, of which we have an aerial view, has been traced in the so-called "world landscapes" of the Dutch artist Joachim Patinir (c. 1485–1524; ill. above), and the sketch-like dynamics of the brushwork and transparency of the colouring are reminiscent of similar pictures by Rubens. Magnificently as the landscape in particular is painted in this picture, the colouring of the later altarpiece seems aesthetically superior and more mature by comparison.

When he painted *The Coronation of the Virgin*, Velázquez was on the threshold to his late work and the peak of his artistic achievement, to which his likenesses of the Spanish Habsburgs, not least, made a considerable contribution. They are among the finest examples of court portraiture ever painted.

Albrecht Dürer
St. Anthony Abbot and St. Paul the Hermit,
c. 1503. Woodcut
New York, The Metropolitan Museum of Art

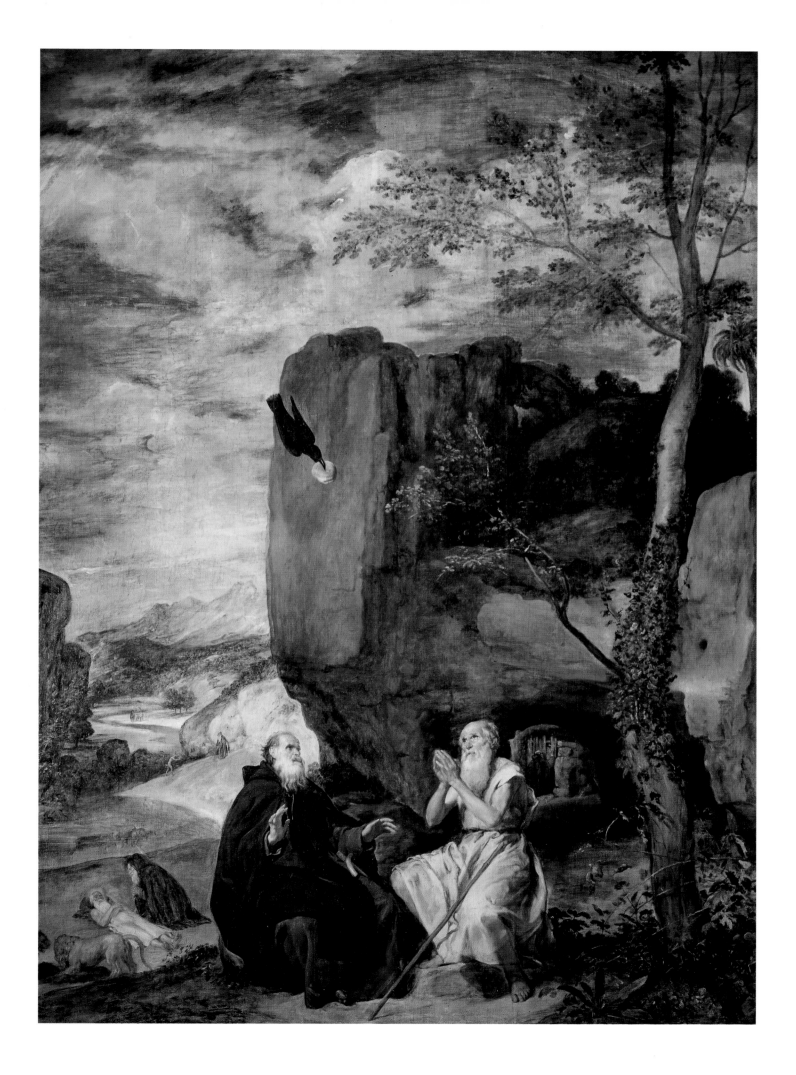

Enigmas and Reflections
– Riddles in Paint

One of the most famous of the paintings by Velázquez, and an example of his great mythological works, is *The Fable of Arachne (Las Hilanderas)* (pp. 69 and 71), now usually dated to the 1640s. It was painted not for the king but for a private patron. In its composition, the artist looks back to his *bodegones*, where two different areas and two planes of reality balance each other. The everyday scene in the foreground shows a plainly furnished room where women are at work spinning. Sunlight falling in from above conjures up a complex range of colours. On the left, an elderly woman is at the spinning wheel, while the young woman seated to the right is winding yarn. One of the figures of naked youths by Michelangelo on the roof of the Sistine Chapel has been identified as the model for her attitude (p. 68). Three other women are bringing more wool and sorting through the remnants.

There is a second room in the background, in an alcove reached by steps. It is flooded with light and contains several elegantly dressed women (p. 71). The woman on the left wearing an antique helmet and with her arm raised is a figure of Athene. Opposite her – either really in the room, or part of the picture in the tapestry on the back wall? – stands the young Arachne, who has committed the sacrilegious act of comparing her skill in weaving with the goddess's. She has begun their competition with a tapestry showing one of the love affairs of Jupiter, the rape of Europa. Velázquez borrowed the theme of this tapestry from a famous picture by Titian, also extant in a copy by Rubens (p. 70), to show his artistic veneration for the Venetian master.

The legend of Arachne derives from the *Metamorphoses* of the Roman poet Ovid, and around 1636 Rubens had painted a version of the same story for the Torre de la Parada, showing the punishment of the less able weaver, when she was turned into a spider. Velázquez omits this detail, instead treating the rivals almost as equals. By comparison with the weight of symbolism in the background scene, he shows the simple work of the women in the foreground with monumental dignity; it is the basis of the technique without which no goddess could practise her arts. This interpretation is still relevant if Velázquez has in fact represented the figures of Athene (now disguised, but with her shapely bare leg indicating her timeless beauty) and Arachne a second time in the figures of the old woman and the young woman in the foreground. Here, at least, Velázquez has transferred mythology to everyday reality. However, there is a whole series of possible

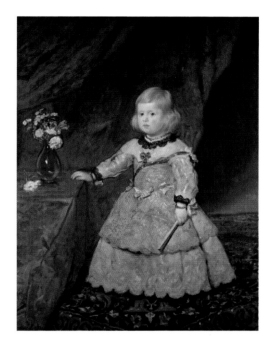

Infanta Margarita, 1653
Oil on canvas, 128.5 x 100 cm
Vienna, Kunsthistorisches Museum

PAGE 66:
Detail from *Infanta Margarita*, 1653

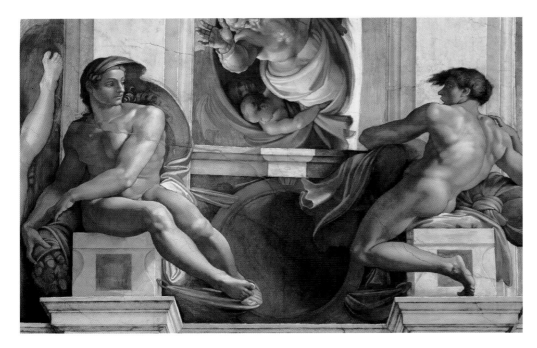

Michelangelo
Ignudi, 1508–1512
Fresco
Vatican, Sistine Chapel

meanings beneath the surface of this painting, and scholars are still puzzling over some of them to this day.

The second picture connected with Arachne (p. 72), painted by Velázquez in 1644–1648, presents something of a problem: what is the dark-haired young woman pointing to on the empty panel in front of her? She may be either Arachne seen as the personification of painting, or a Sibyl or prophetess pointing to the future.

Velázquez himself becomes almost another Arachne in his ability to interweave light and shade, form and colour in rivalry with the gods of art themselves, while concealing mysterious signs and meanings in the texture of his work – although to say so contradicts the idea of him that was later criticized by Classicists but praised by the Impressionists when they claimed that he was not concerned with artistic ideologies, but owed allegiance only to what he actually saw in nature.

That concept of an uneducated painter following only the dictates of his eyesight seemed to be supported by the fact that Velázquez hardly figures at all in seventeenth-century European art theory, and he clearly obeyed no academic rules of the kind most notably formulated in the Italian Renaissance. On the other hand, since publication in 1925 of the contents of Velázquez' private library, which contained 156 learned works, it has been obvious that he did have an extensive fund of knowledge. His references to classical mythology, for instance in the painting *Mercury and Argus* of around 1659 (p. 73), should be viewed in this light.

Philip IV's court painter obviously had an educated mind that was reflected in many of his works in the coded form of complex riddling structures, even in a picture on such a simple subject as *Venus at her Mirror* (pp. 74/75). This gracefully erotic depiction of a feminine nude appears to be one of the most perfect such pictures in European art purely because of the flowing form of the goddess's body lying at ease on the grey fabric, the virtuoso painting and the magnificent colour. Yet art historians today agree that the comparison between the real back view of the goddess of

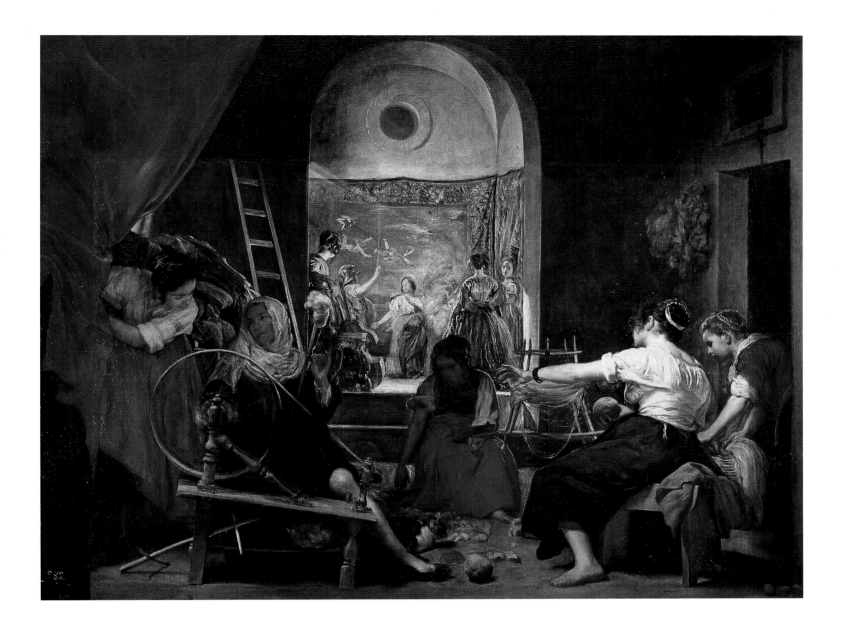

love and the reflection of her face, blurred as if in a dream (it was in fact painted over at a later date), in a mirror held up by Cupid, intends to explore the relationship between reality, reflection and image. Velázquez reflects on the possibilities of painting by using the methods of painting itself, situating it somewhere between reality and brilliant appearance: in short, his thinking on the medium of the image and the process of creating it is both intellectual and sensual.

In January 1649 a small flotilla put out to sea from Málaga. One of those on board was Diego Velázquez, on his way to Italy for the second time. He wished to pay another visit to a country that was so rich in art, and he had also been commissioned to buy pictures and casts of classical statues in Rome for Philip IV's collections. He met the most famous Italian artists of the time in the capital, and tried unsuccessfully to entice some of them to Madrid. He also showed his own skill in many portraits painted while he was in Rome.

It was at this time that he painted his fine portrait of the half-caste *Juan de Pareja* (p. 76). The sitter was an assistant in Velázquez' workshop, where he was employed on minor tasks. The flesh tints of the face looking challengingly out of the frame are heightened with bold brushstrokes.

The Fable of Arachne (Las Hilanderas), c. 1644–1648
Oil on canvas [167 x 252 cm] 222.5 x 293 cm (with additional strips)
Madrid, Museo del Prado

There were two editions of Ovid's *Metamorphoses* in the library owned by Velázquez. In this work, Ovid tells the story of the rivalry between Pallas Athene and Arachne. Arachne, shown as the young woman on the right, made six tapestries depicting gods abducting mortals, beginning with Europa abducted by Zeus in the shape of a bull. The radiant apparition of the young woman by far outshines the goddess Athene beside her.

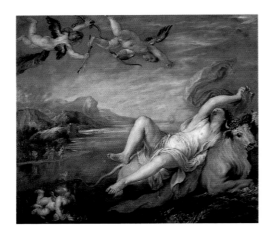

Peter Paul Rubens
The Rape of Europa (copy from Titian),
1628/29
Oil on canvas, 181 x 200 cm
Madrid, Museo del Prado

The model admired all over Europe, Titian's
Rape of Europa, was in the royal palace in
Madrid in the seventeenth century. Rubens
copied the painting, and so did Juan Bautista
Mazo, Velázquez' son-in-law.

PAGE 71:
Detail from **The Fable of Arachne**
(Las Hilanderas), c. 1644–1648

Athene, disguised as an old woman, visited
Arachne to warn her of her sacrilegious
challenge. When Arachne was unmoved, the
goddess threw off her disguise and revealed
herself in helmet and armour. It is not clear
whether the other women in the alcove with
Arachne symbolize the four fine arts.

A wide white collar with a jagged border contrasts effectively with the black of the model's hair and beard and his copper-coloured complexion. The dark eyes glow with great expressive force. If we compare this portrait with some of Velázquez' more routine work of a later date (p. 77), its outstanding quality is particularly striking.

According to an eye-witness, this half-length portrait of Pareja was displayed in the Pantheon in Rome during the celebrations of the Feast of St. Joseph on 19 March 1650, and met with unreserved admiration from artists of many different nationalities. It won admission to the Roman Academy for the Spanish court painter, serving Velázquez as a kind of *entrée*, and he could expect its success to bring him commissions to paint some very distinguished people. Sure enough, the Pope himself was soon sitting for him, and so were members of the papal household down to the *So-Called Barber to the Pope* (p. 78), whose rather smug expression has sometimes been taken to show that the portrait is actually of a buffoon. Under a thick layer of dust and dirt, the portrait of *Camillo Massimi* (p. 79) also shows the fine qualities indicating that it was executed by Velázquez himself.

However, the picture that attracted most attention of all was the portrait of the artistically minded Pope Innocent X, completed by Velázquez in the spring of 1650 (p. 80). This work is one of his absolute masterpieces. Pope Innocent wears the white liturgical under-vestment known as an alb, a biretta, and a red cape to which subdued highlights lend a sheen suggesting the texture of fabric. The Pope is seated in a red armchair, which is picked out from the opulent red of the curtain behind it by its gilded ornamentation. In the strong, almost rustic features of the Pope's reddened face with its fleshy cheeks, the critically keen suspicious eyes strike a note of lively intelligence. The fascinating nature of a man aware of his own power is wonderfully expressed in the contrast between the face and the fine nervous hands, which convey the sensitivity of this powerful figure.

Pope Innocent, aged seventy-five at the time, was a man of remarkable vigour, with a great capacity for work and a hot and violent temper. The emotional coldness and relentless contempt for humanity of this successor of St. Peter sent the twentieth-century English artist Francis Bacon to Velázquez' picture as a model to illustrate the deformities of the human mind (p. 81).

This painting by Velázquez is primarily a symphony in red, a harmonious mingling of all kinds of red shades flowing into each other, while the alb provides a contrast in its creamy white cascades of pleats. In general the pigments are very fluid, applied as impasto only in a few places. It is as if the colouring represents not only magnificence and dignity but also the latent and sometimes violent passions so often connected with the office of the Holy See, and exemplified in the person of Pope Innocent. It is almost impossible to understand how Velázquez created so life-like an image of a man, and indeed of an entire age, while still preserving a discreet distance.

Apparently the Pope was not at first very enthusiastic about his portrait, describing it as *troppo vero*, "too real". However, we are told that it eventually won his approval, and he presented the Spanish painter with a very valuable gold chain. Velázquez himself must presumably have been

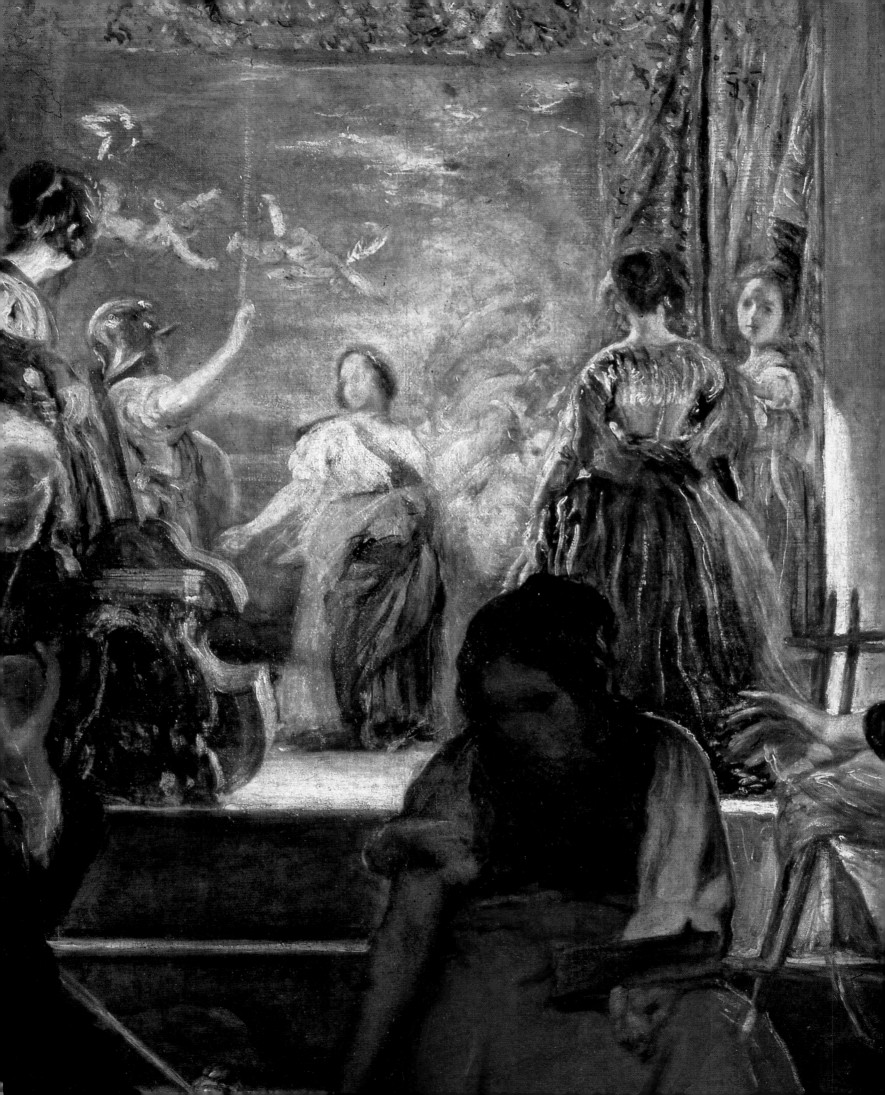

Arachne (A Sibyl?), c. 1644–1648
Oil on canvas, 64 x 58 cm
Dallas, Meadows Museum, Southern
Methodist University

very pleased with the portrait, or he would not have taken a replica back to Spain with him. His art colleagues certainly praised it, and many copies of the work were made. Pietro Martire Neri (1591–1661) was particularly active here (p. 78); he was one of the circle around Velázquez in Rome and also painted the portrait of *Cristoforo Segni*, the Pope's major-domo (p. 79), which is obviously based on a lost sketch by the master.

Philip IV wanted his favourite court painter, now enjoying such a triumph in Rome – although he did not found a stylistic school there – to paint his second wife, Queen Mariana, and to give his advice on the renovation of the old royal palace in Madrid, the Alcázar. Consequently, he wished Velázquez to come back to court as soon as possible, but none the less the artist delayed his return for another whole year.

The portrait of *Queen Mariana* required by the king (p. 82) was not completed until 1653. The queen was the daughter of Emperor Ferdinand III and Philip's sister the Infanta Maria, and had married her widowed uncle in 1649. She was nineteen at the time of this portrait, which shows her full length, wearing a black dress with silver braid, and of course adorned with much valuable jewellery: gold necklaces and bracelets, and a large gold brooch on her close-fitting bodice. Her right hand rests on the back of a chair, and she holds a delicate lace scarf in her left hand (p. 83). The picture is bathed in harmonious shades of black and red, although the dramatically drawn curtain has been painted over by another hand.

The composition turns on the focal point of the queen's alabaster skin and rouged face, small and almost doll-like under her hair, which is dressed very wide (pp. 84 and 85). Her bust, tightly encased in the bodice, her stiff farthingale and all her fashionable magnificence are rendered true to life by Velázquez, and at the same time he reveals them as a theatrical show concealing the girl's natural physical nature beneath the armour of courtly constraint. The court that Velázquez had now served for many years was the only sphere in which he had lived and worked since his youth in Seville. Art historians have engaged in much controversy over the artist's social ambitions.

PAGES 74/75:
Venus at her Mirror, c. 1644–1648
Oil on canvas, 122.5 x 177 cm
London, The Trustees of the National Gallery

The painting shows traces of damage from old tears and worn paint, and it was slashed by a campaigning suffragette in 1914.

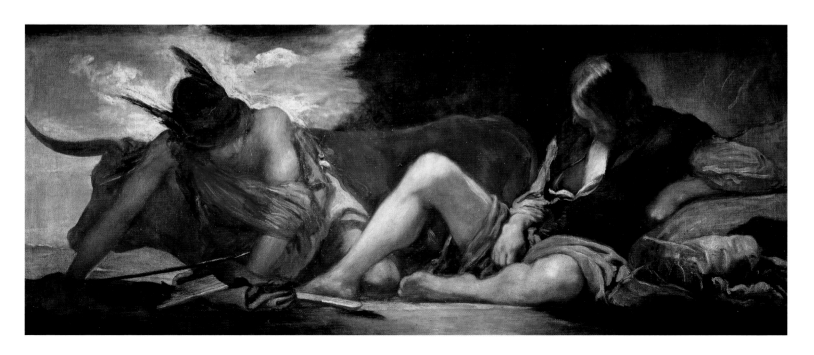

Mercury and Argus, c. 1659
Oil on canvas, 128 x 250 cm
Madrid, Museo del Prado

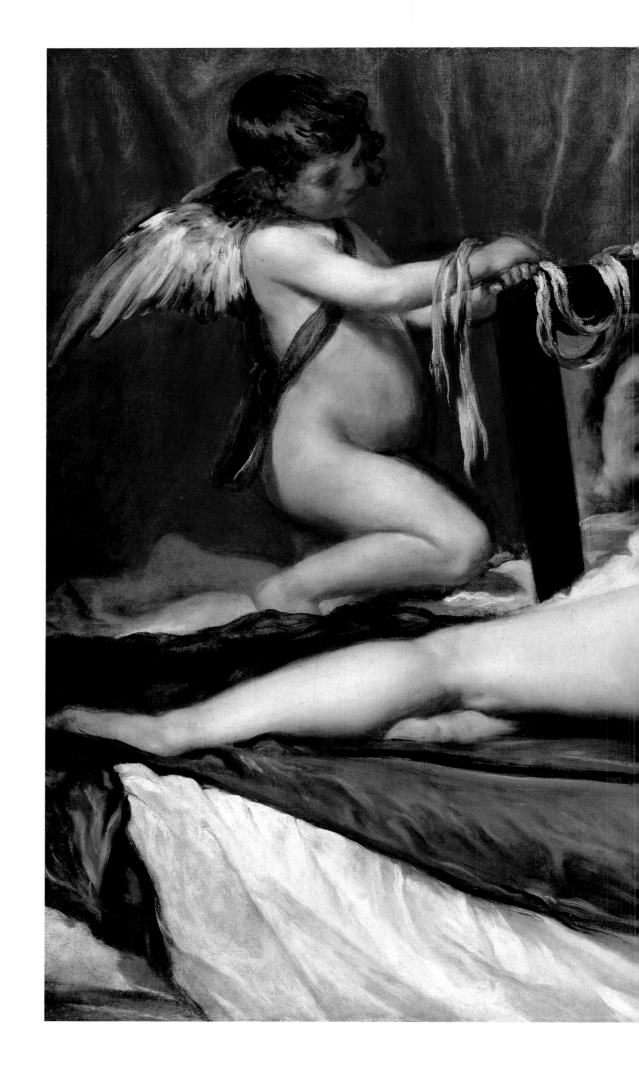

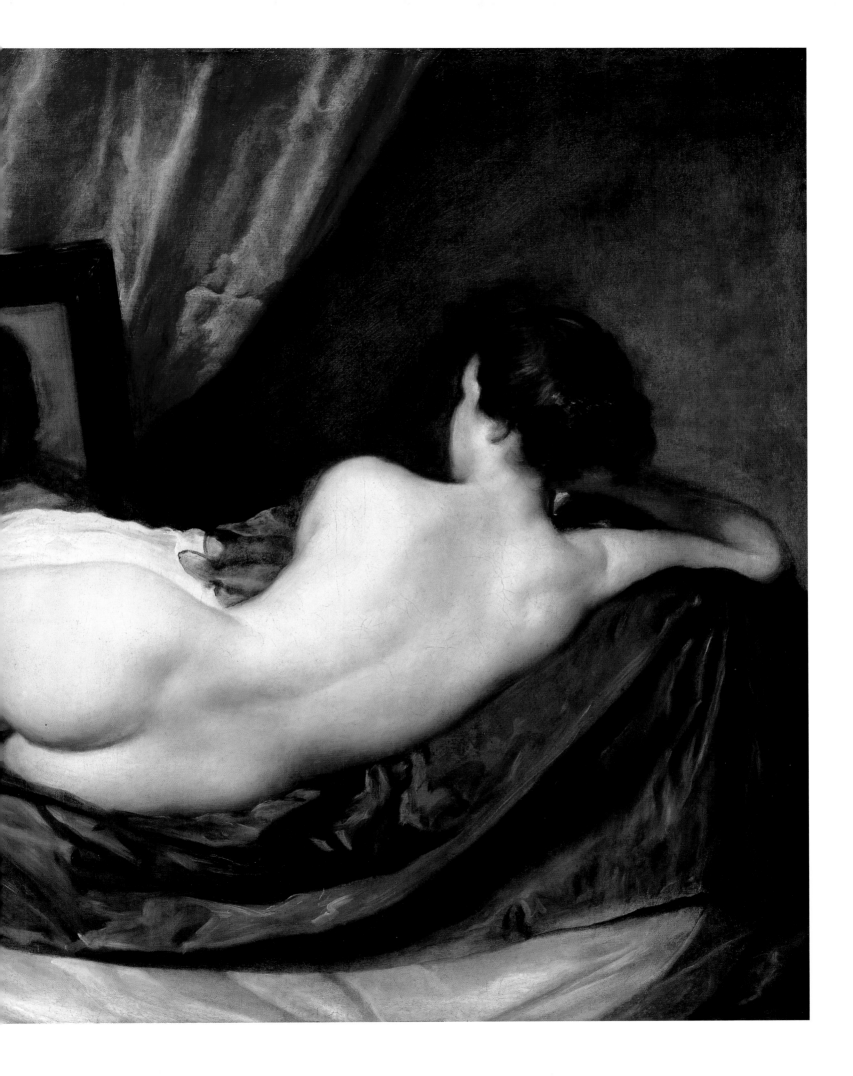

Juan de Pareja, 1649/50
Oil on canvas, 81.3 x 69.9 cm
New York, The Metropolitan Museum of Art,
Fletcher Fund, Rogers Fund, and Bequest of
Miss Adelaide Milton de Groot (1876–1967),
by exchange supplemented by gifts from
friends of the Museum

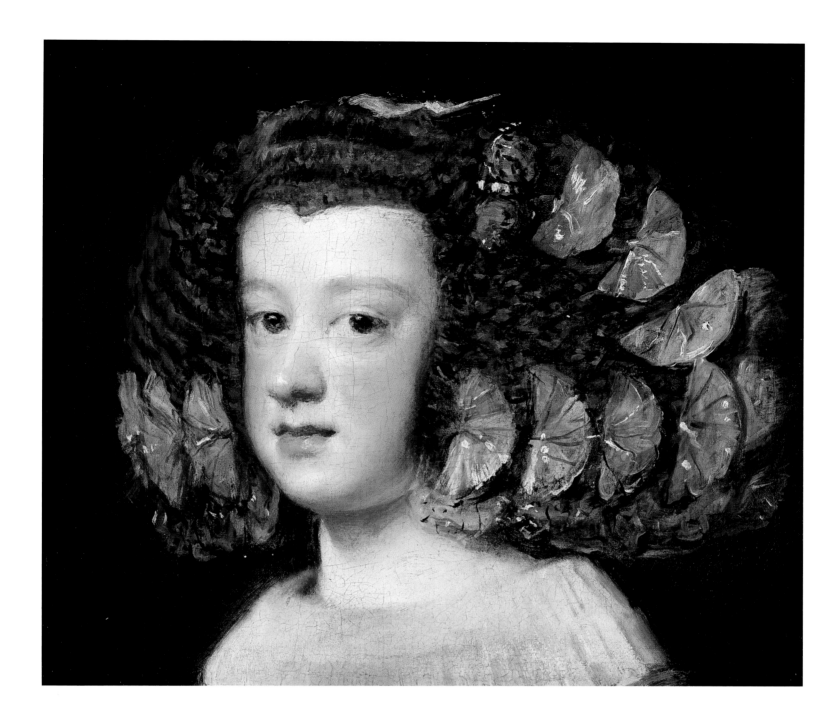

The Spanish cultural philosopher Ortega y Gasset, for instance, suggested in 1955 that there was only one factor of any real significance in the life of Velázquez: his appointment as court painter. In an outwardly uneventful existence he had only one wife, only one friend (the king), and only one studio (the palace). Self-confident and self-sufficient, he neither joined the games of precedence played at court nor pursued his own fame. The nobility in his painting has also been seen by many writers as resulting from his own social position as a member of the Spanish aristocracy. However, a whole series of documents provides evidence that Velázquez was by no means just a generally admired artistic genius and a morally superior aristocrat. For instance, a royal decree of the year 1628 allots the court painter the same daily ration of food as the barbers received, and he was always having to do battle to get money that was owed to him – although it must be admitted that the Count-Duke of Olivares too was in the same position.

Infanta María Teresa, 1651/52
Oil on canvas, 44.5 x 40 cm
New York, The Metropolitan Museum of Art,
The Jules Bache Collection

So-Called Barber to the Pope (detail), 1650
Oil on canvas, 50.5 x 47 cm
New York, private collection

<u>Pietro Martire Neri</u>
Innocent X with a Prelate, 1650–1655
Oil on canvas, 213 x 167 cm
Madrid, Patrimonio Nacional, Monasterio de
San Lorenzo de El Escorial

Velázquez probably owed his undeniably high regard at the court of Philip IV more to the official positions he gradually accumulated than to his artistic importance. His appointment by the king to the post of Chamberlain in 1652, despite the veto of the palace administration, was probably less in recognition of his professional achievements as a painter than for the architectural advice he had also given since the mid-1640s. His biographer Antonio Palomino deplored these official pursuits on the grounds that they left the court painter hardly any time for his real artistic work.

Even when he had attained the highest offices, Velázquez was not entirely the enlightened, magnanimous courtier impervious to flattery that later claims would have it. On the contrary: he would tolerate no other painters around him except his son-in-law, and he did not allow his gifted Moorish slave Pareja (p. 76) to exercise his own creative skills. As compensation for the irregular payment of his salary, Velázquez took his chance to divert to himself part of the money due to subordinate employees, who went on strike over the matter in 1659. By the time of his death, the court

Camillo Massimi (detail), 1650
Oil on canvas, 73.6 x 58.5 cm
London, The National Trust, Kingston Lacy
(Bankes Collection)

Pietro Martire Neri
Cristoforo Segni, c. 1652
Oil on canvas, 114 x 92 cm
Switzerland, private collection

During his second visit to the Italian capital Velázquez was much admired by the painters of Rome, including Pietro Martire Neri, and it is surprising that none of them followed him back to Spain. It was with Spanish artists alone that Velázquez was able to form a kind of school.

painter had accumulated 3,200 ducats in this way, although the palace owed him only 1,600 ducats.

In 1658 the king, according to Palomino, decided to invest Velázquez with a knightly order. There were three military orders available to choose from, and Diego, so his biographer, decided on the *Orden militar de la Caballería de Santiago*. Since no one could enter a military order unless his family sprang from "old Christian" roots, without any Moorish or Jewish blood in the family tree, there had to be complicated investigations into the artist's ancestry. Furthermore, all members of the family must be hidalgos: that is to say, they must not work for money, so that anyone who engaged in commerce or trade – including the trade of painting – did not qualify. Velázquez' struggle for admittance to these socially exclusive ranks was thus a difficult one. A hundred and forty-eight witnesses were questioned, including many who were well disposed to him, but without the whole-hearted support of the king and the consent of the Pope it is likely that Velázquez would never have become a knight of the Order of Santiago.

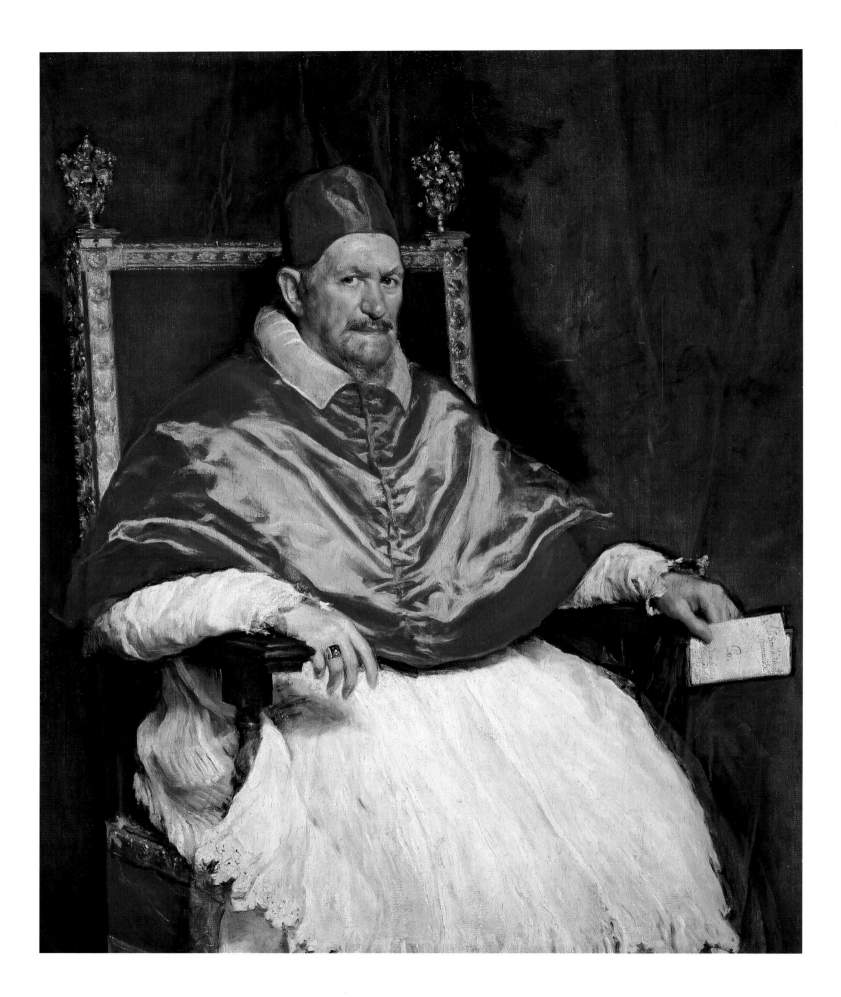

Very likely none of these events would have been of any importance for modern students of his work if they had not, as has often been assumed, been reflected in the most famous of Velázquez' paintings, his undisputed masterpiece, described by the Neapolitan painter Luca Giordano (1634–1705) as the "theology of painting". This was his monumental work *Las Meninas* or *The Royal Family*, painted in 1656/57 (p. 86).

Las Meninas is one of the great problem pictures in the history of art. An almost infinite number of interpretations have now been proposed for the scene it shows, and countless painters, from the seventeenth century to Francisco de Goya, Edgar Degas and Edouard Manet, Max Liebermann and Franz von Stuck at a later date, with Salvador Dalí and Richard Hamilton in modern times, have felt inspired by this picture to offer their own versions and studies of it. Most notably, Pablo Picasso (1881–1973) vividly updated the picture in a fifty-eight part series (p. 87). At first sight, however, *Las Meninas* seems to present no problems at all, and indeed appears perfectly straightforward in its sober geometry and good-humoured clarity.

It is set in a room in the Alcázar, equipped by Velázquez as a studio, and shows the heiress to the throne, the Infanta Margarita (p. 91), with her court. Palomino names all those present. The queen's maid of honour (p. 90), Doña María Agustina Sarmiento, one of the *meninas*, is kneeling at the Infanta's feet, handing her a jug of water. The other maid of honour, Doña Isabel de Velasco (p. 89) stands behind the princess, and beside her we see the grotesquely misshapen female dwarf Mari-Bárbola and the male dwarf Nicolasico Pertusato; the latter, as Palomino points out, is placing his foot on the mastiff lying in front of the group to demonstrate the lethargic animal's good temper. Further back, almost swallowed up in the shadows, are a man described only as *guardadamas* – a guard or escort to the ladies – and the lady in waiting Doña Marcela de Ulloa.

Velázquez is standing with brush and palette in front of a tall canvas; we can see only the back of it. There are some large pictures hanging on the back wall of the room. Two of them were painted by Velázquez' son-in-law, Mazo, from models by Rubens, and show scenes from Ovid's *Metamorphoses*, one of them another version of the punishment of Arachne. The princess's parents, the king and queen, appear in a dark frame below these pictures, probably the glass of a mirror. To the right of the mirror, on a flight of steps leading up to a doorway and a brightly lit adjoining room, stands José Nieto, the queen's palace marshal (p. 89).

There are several basic questions that have been asked again and again about this picture. What is Velázquez painting on the front of the canvas that is hidden from us? Where did he stand in order to paint the scene and himself in it? What is the source of the image in the mirror – that is, just where in the room must the royal couple have been standing for their reflection to appear? And finally, is there any significance in the fact that the red cross of the Order of Santiago is prominently applied to the artist's clothing?

It was long thought that Velázquez – whom the Impressionists claimed as a forerunner – was creating a picture without any metaphysical or speculative reference, and was merely recording a fleeting moment in permanent form, as if in a snapshot. According to this theory the subject was no more than an ordinary scene of palace life.

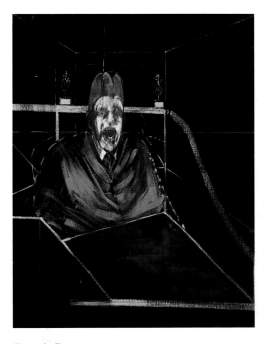

Francis Bacon
No. VII of Eight Studies for a Portrait, 1953
Oil on canvas, 153 x 118 cm
New York, The Museum of Modern Art

PAGE 80:
Innocent X, 1650
Oil on canvas, 140 x 120 cm
Rome, Galleria Doria-Pamphilj

With this portrait Velázquez joins the ranks of those painters who, from the Renaissance onwards, produced magnificent papal likenesses. Outstanding examples, which he must have known, were Raphael's portraits of Pope Julius II (c. 1511/12; London, National Gallery), and Pope Leo X with two cardinals (1518/19; Florence, Galleria degli Uffizi), and several pictures by Titian of Pope Paul III, still extant in Naples.

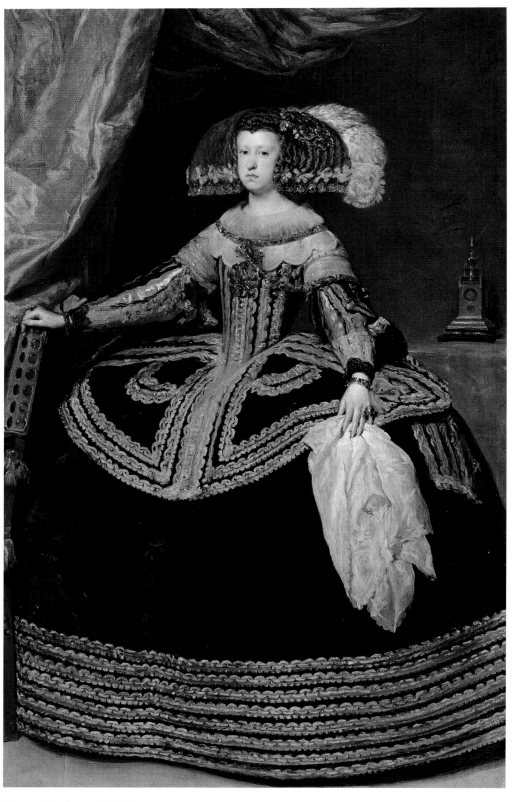

Queen Mariana, 1652/53
Oil on canvas, 234 x 131.5 cm
Madrid, Museo del Prado

PAGES 83 AND 84/85:
Detail from *Queen Mariana*, 1652/53

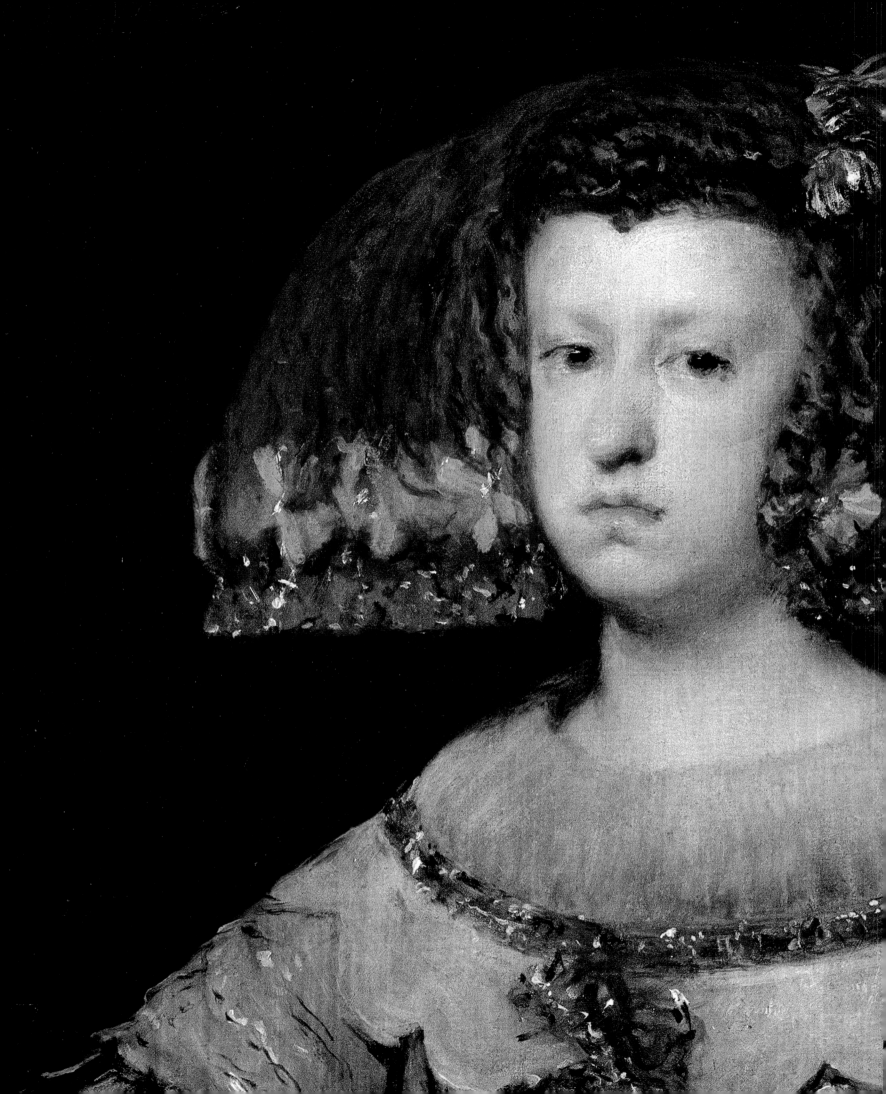

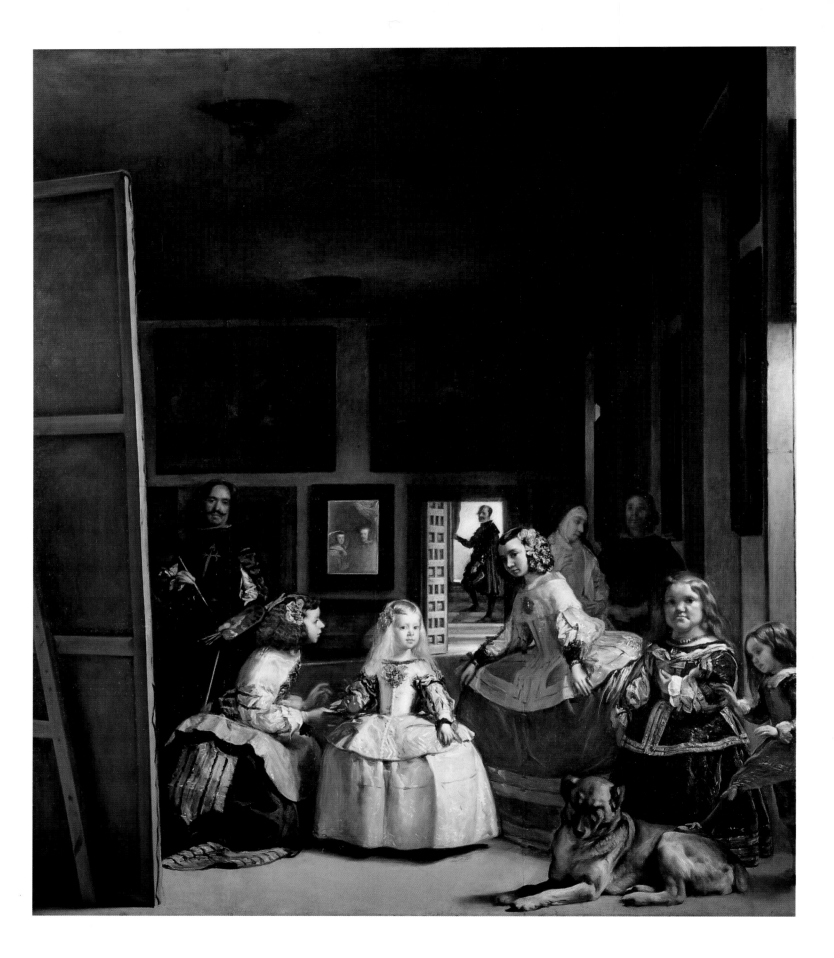

Their Majesties were sitting for the painter one day when the Infanta was called in to entertain them; she and her retinue are looking at the royal couple, directly visible only to them and to the painter, but seen half-length in the mirror by viewers of the picture, while the palace marshal is turning enquiringly back to the king and queen as he leaves the room.

A different hypothesis is put forward by art historians, who believe that intellect and keen perspicacity, as well as the artist's eye and hand, were involved in the painting of *Las Meninas*. They have studied the work for possible models, without coming to any particularly sensational conclusions. It has been possible only to establish that Velázquez knew the portrait of *The Marriage of Giovanni Arnolfini* painted by Jan van Eyck (c. 1390–1441) in 1434 (p. 88), which was in Madrid at the time, and may well have picked up from it the idea of a mirror showing people who are not depicted in the room.

The question is, why would Velázquez have chosen to give an intellectualized rendering of his subject? One answer holds that the picture has a poetic rather than a documentary meaning. Velázquez has painted a portrait *about* the painting of a portrait, or as in *Las Hilanderas* (pp. 69 and 71), he has painted a picture about the making of pictures, and that is why he has placed himself in such a prominent position – to glorify his activity, his art, and himself as an independent creative artist. That is also, according to this theory, why Luca Giordano saw the composition as the "theology of painting", the highest form of intellectual or even philosophical concern with art.

The largest number of interpretations have been put forward for the mirror on the back wall, sometimes also thought to be a painted canvas. The theory above holds that the mirror, as a conventional attribute of Prudentia or Wisdom, indicates the wisdom of the royal couple and makes the whole picture the expression of elevated doctrines of virtue: it is a painted "mirror of princes". Velázquez did not show himself painting King Philip and his wife – double portraits were not usual in Spanish court painting of the time – but the royal reflection in the mirror, bathed in light, stands for the supreme and almost divine virtues of the monarchy. Scholars have also wondered whether the laws of optics actually allow the royal couple in front of Velázquez to be reflected – and whether the dimensions of the canvas on the easel are suitable for a double portrait. But what else can the painter be depicting on his canvas? The Infanta? The scene we ourselves see as we look at his picture? Or nothing at all? Countless investigations and mathematical studies of the perspective in *Las Meninas* by architects and engineers, art historians and theatrical experts, show that the vanishing-point of the composition is the open doorway in the background, which would also suggest that the source of the reflection in the mirror, in line with the laws of optics, is not directly opposite it but further left. The reflection of the royal couple in the mirror thus seems to be vanishing out of reach.

Much learned industry has also been applied to the question of location: in which room in the palace is this scene taking place? Although the Alcázar burned down in 1734, it has been possible to locate the site of the room in its historical ground plan. The reconstruction of the room itself, however, is a matter of controversy. In view of the nature of the picture, one recurrent problem is, of course, how a court painter's social position could

Pablo Picasso
Las Meninas – after Velázquez (detail), 1957
Oil on canvas, 194 x 260 cm
Barcelona, Museu Picasso

PAGE 86:
Las Meninas or *The Royal Family*, 1656/57
Oil on canvas, 318 x 276 cm
Madrid, Museo del Prado

X-rays of this painting have shown that while Velázquez made many alterations to the composition while he was working on it, there is nothing to indicate that he wished to depict himself as if looking at the Infanta or anyone else in the group behind which he is standing.

Jan van Eyck
The Marriage of Giovanni Arnolfini (detail),
1434
Tempera on wood, 81.8 x 59.7 cm
London, National Gallery

The witnesses to the wedding of the Florentine
merchant Arnolfini appear in the convex mir-
ror on the back wall of the bedroom, includ-
ing, as the inscription above the mirror con-
firms, the painter of the picture, Jan van Eyck.

PAGES 89 AND 90/91:
Details from *Las Meninas* or *The Royal
Family*, 1656/57

María Sarmientio is giving her mistress, the
Infanta Margarita, water in a *búcaro*, a red pot-
tery jug, handing it to her on a tray. The chil-
dren of Philip IV and his first wife Isabel de
Bourbon were dead by the date of this paint-
ing, except for the eighteen-year-old Infanta
María Teresa, who is not shown in this group.
Philip married Mariana as his second wife in
1649, and at the time this picture was painted
the Infanta Margarita, born on 12 July 1651,
was her only child. The little princess's face is
shown in an aura of almost other-worldly
beauty such as Velázquez hardly achieved in
any other work.

allow him to depict himself so prominently in this picture, actually within
the circle of the royal family, while the king and queen themselves are
shown only indirectly.

Palomino says that the king thought particularly highly of *Las Meninas*
when it was completed, so clearly Philip did not feel offended in any way
by the picture, and indeed he probably gave the concept his blessing in ad-
vance. It is unthinkable that Velázquez would not have observed the requis-
ite standards of etiquette in his painting. But there are widely divergent
opinions of the way in which he expressed those standards, and specula-
tions on the extent to which he may have been secretly undermining them.
The glance that the painter turns on us from this picture certainly has
nothing of the subservient courtier about it. He radiates pride and self-
confidence – and is looking unwaveringly at the person opposite him,
whoever that may be.

The story goes that when Velázquez died, the king had *Las Meninas*
brought to his deathbed and with his own hands added the cross of the
Order of Santiago to the court painter's clothing in red paint. This is only a
legend, of course, although the sign of the order was indeed added later,
since the artist was not knighted until 1659. However the cross came to be
added, there is an artistic density in this painting that can probably never be
fully explored and is therefore certain to produce more new interpretations
in the future.

We know that Velázquez was qualified to wear the red cross of San-
tiago on his cloak over clothing adorned with silver lace, and to carry a
valuable dagger at his side and wear a heavy gold chain with a scallop
shell set with diamonds around his neck, by the time he mingled with the
dazzling company that assembled on the Isle of Pheasants in the river
Bidassoa on the Spanish-French border on 7 June 1660, to celebrate the
wedding of the Sun King, Louis XIV of France, to the Spanish princess
María Teresa. Towards the end of his life Velázquez had brought both his
career and his art to the zenith of achievement. Despite the riddles hidden
in the painting of *Las Meninas* we must not overlook its artistic mastery,
particularly as expressed in the figure of the Infanta Margarita sur-
rounded by people of lesser birth. For it was on the princess that the dy-
nastic hopes of the Spanish Habsburgs rested after the death of Prince
Baltasar Carlos.

A portrait of the Infanta is one of the last works Velázquez painted
(1659; Vienna, Kunsthistorisches Museum). It was sent to Vienna, to the
German Emperor Leopold I, to whom the princess was betrothed, and with
it went the portrait of *Prince Felipe Próspero* (p. 93), also painted by the
master in 1659. The young prince was a sickly child from birth, and he died
at the age of four. He appears in this picture in a pink dress trimmed with
silver, with a translucent pinafore over it, and bearing some striking acces-
sories: various amulets were supposed to protect him against the evil eye,
and an amber apple was thought to ward off infections. The bloodless face
of the blue-eyed prince looks even paler due to the contrast with the silver
highlights in his straw-coloured fair hair. Pale daylight falls in through the
open door in the background. Otherwise, the room is full of shadows that
seem to threaten the little figure. Palomino considered this portrait one of
the finest ever painted by Velázquez, and singled out the little dog on the
chair for special praise (p. 92).

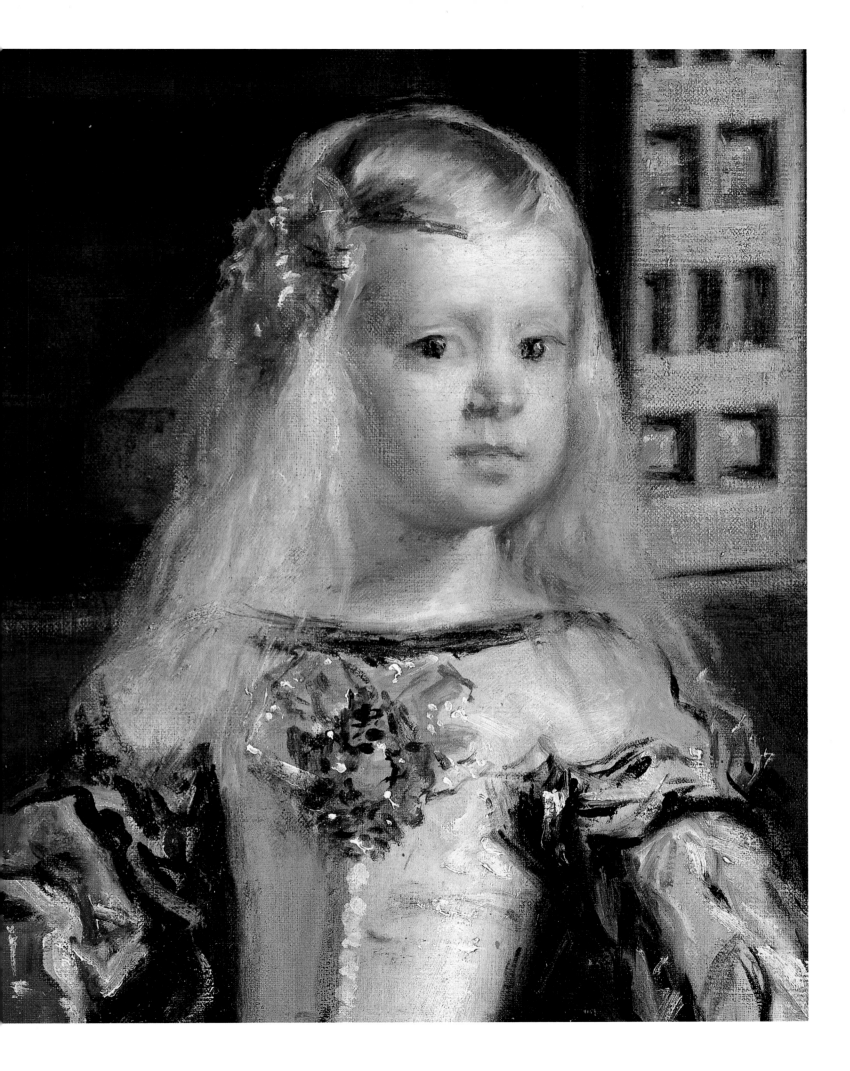

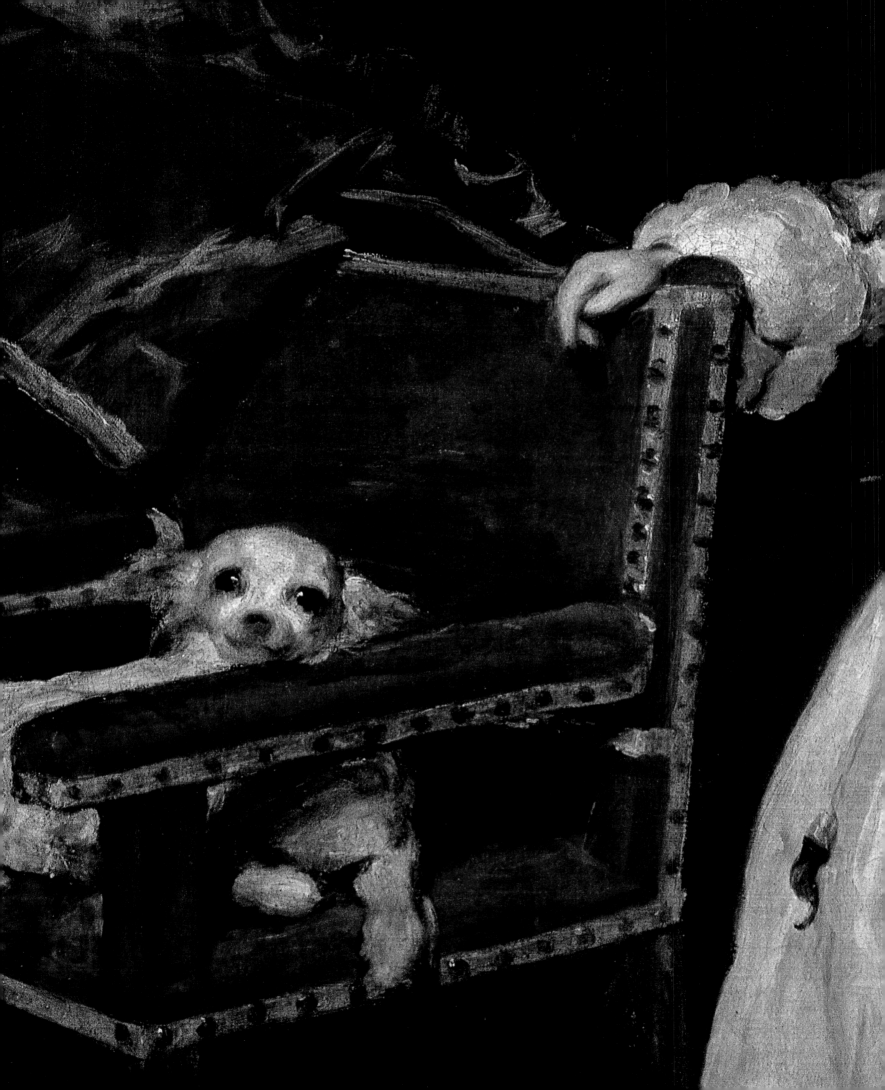

This portrait of the prince is the first in which Velázquez expresses a strong sense of sadness, as if he guessed that he himself would not paint many more pictures: no more divine figures and kings, no hidalgos, dwarfs and jesters, no more popes and saints, and no more simple, ordinary folk – with all of whom he had filled his canvases, turning the same intensity and sensitivity on each of his subjects.

Prince Felipe Próspero, 1659
Oil on canvas, 128.5 x 99.5 cm
Vienna, Kunsthistorisches Museum

PAGE 92:
Detail from *Prince Felipe Próspero*, 1659

Velázquez died on 6 August 1660. One of the greatest figures in the history of art was laid out in the Alcázar, wrapped in the cloak of the Order of Santiago. He was buried by night in the church of San Juan Bautista, and many noble and royal dignitaries attended the solemn funeral service. His wife survived him by only a week, and was buried beside him. There is nothing left today of either the church or the grave of Velázquez. But we still have his pictures.

Life and Work

1599 Birth in Seville of Diego Velázquez, the first child of Juan Rodríguez de Silva and Jerónima Velázquez, members of the lesser nobility. His grandparents had come to Spain from the Portuguese harbour city of Porto. Little is known about Diego's siblings – five brothers and a sister. In accordance with the practice of the times, the young Diego was educated in the humanities.

1611 Velázquez' father comes to an agreement with Francisco Pacheco on the details of Diego's training with that painter. In his biography of Velázquez, Palomino states that Diego had previously spent a short time studying with Francisco de Herrera the Elder. Poets and scholars as well as artists met at Pacheco's workshop, in an intellectual climate where there was enthusiastic discussion of such subjects as artists of classical antiquity, Raphael, Michelangelo and above all Titian, as well as the theory of art. At this time, Velázquez became familiar with the chiaroscuro painting and naturalistic subjects of the school of Caravaggio.

Self-Portrait as Royal Chamberlain, n.d.
Oil on canvas, 101 x 81 cm
Florence, Galleria degli Uffizi

1617 Velázquez is accepted into the painters' guild of St. Luke in Seville, after passing an examination assessed by Pacheco and a painter called Juan de Uceda. Membership of this guild was necessary before he could found his own workshop, employ assistants, and receive commissions from churches and public institutions. On 23 April Velázquez marries Juana, daughter of his teacher Pacheco, who brings several houses in Seville to the marriage as her dowry. Within less than three years they have two daughters, of whom only one, Francisca, survives. Few of the twenty or so paintings executed by Velázquez in Seville before 1622 are dated and signed; they include nine *bodegones* and his first portraits and religious compositions. Even later, he usually omitted to add dates and signatures.

1622 Velázquez goes to Madrid for the first time to see the monastery palace of the Escorial near the capital, and its art treasures. He also wishes to paint the new king of Spain, the seventeen-year-old Philip IV, who has been on the throne for a year. Rodrigo de Villandrando, until now the most highly regarded of the court painters, dies at the end of the year. Velázquez visits Toledo to see works by El Greco and other painters of that city, including Pedro de Orrente (1580–1645) and Juan Sánchez Cotán (1561–1627).

1623 Velázquez is summoned to court by Olivares in the spring, and receives his first commission for a portrait of Philip IV. The success of this picture brings the artist an appointment as court painter and the privilege of becoming the only artist permitted to paint the king in the future. His brilliant career has begun.

1627 Philip IV organizes an artistic competition between his four official court painters; Velázquez emerges victorious.

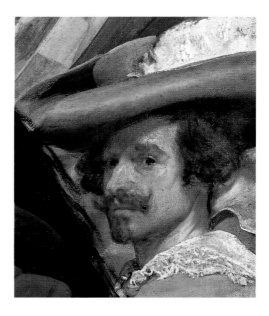

Self-Portrait from *The Surrender of Breda (Las Lanzas)*, 1634/35

Besides various hostile reactions from his rivals, this success brings him an appointment as Usher of the Chamber, an office with the privileges of free board and free medical treatment.

1628 Peter Paul Rubens pays a second visit to the court in Madrid on diplomatic business. A studio is placed at his disposal in the Alcázar, where Velázquez often visits him at work. Velázquez is the only Spanish painter to be honoured with these personal conversations.

1629 His first journey to Italy takes Velázquez from Genoa to Venice, and then probably to Florence on his way to Rome, where he stays for almost a year. Neither Pope Urban VIII nor other ecclesiastical dignitaries seem to take any interest in his work at this point. He copies old masters, but also paints large compositions of his own including *The Forge of Vulcan* and *Joseph's Bloody Coat Brought to Jacob*. He travels home by way of Naples.

1631 Velázquez' daughter Francisca, aged fourteen, marries the painter Juan Bautista Martínez del Mazo.

1635 The Salón de Reinos in the new palace of Buen Retiro in Madrid is completed. Velázquez has been working on

Self-Portrait from *Las Meninas* or *The Royal Family*, 1656/57

its artistic decoration for the past year. One of his major works intended for this setting, together with several equestrian portraits, is *The Surrender of Breda*, part of a cycle of twelve battle pictures by different painters. The art of Velázquez wins increasing admiration at court.

1636 The hunting lodge of Torre de la Parada, near Madrid, is extended and ornamented with many pictures from the workshop of Rubens, as well as hunting portraits, portraits of dwarfs, and pictures of the classical god of war Mars and of Aesop and Menippus by Velázquez. The king appoints his court painter "Assistant to the Wardrobe" (without salary).

1643 The Count of Olivares is dismissed from his position as prime minister and banished from court. Shortly before this time, the king promoted Velázquez to the post of Chamberlain in his private chambers (although still without a regular salary). Later he is made assistant to the superintendent of special building projects. In the next few years his art approaches its peak in such pictures as

Juan Bautista Martínez del Mazo
The Artist's Family, c. 1660–1665
Oil on canvas, 150 x 172 cm
Vienna, Kunsthistorisches Museum

Venus at her Mirror and *The Fable of Arachne*.

1646 At the beginning of this year the king's sister Maria dies; she had been married to Emperor Ferdinand III. Towards the end of the year the king's wife Queen Isabel and the heir to the throne, the young Prince Baltasar Carlos, both die.

1649 Velázquez travels to Italy again. His main destination is Rome, where, among other pictures, he paints the famous portrait of Pope Innocent X.

1650 Velázquez is admitted to the Academy of Rome.

1651 Velázquez returns to Madrid, where he is to paint a portrait of the new Queen Mariana, Philip's second wife, although he does not complete it until 1652. He is appointed Supreme Court Marshal out of a list of six candidates. He is now able to move into a large apartment in the Casa del Tesoro, linked by a passage to the royal palace, where he has already had his workshop for years, employing many assistants and pupils (none of whom, however, was of very great artistic merit).

1652 Probably in this year, an illegitimate son of Velázquez with the first name of Antonio is born in Rome.

1656 Velázquez begins work on his great masterpiece, *Las Meninas*.

1659 After many enquiries into the details of his ancestry, Velázquez is admitted to the knightly Order of Santiago.

1660 Velázquez dies in the palace in Madrid on 6 August.

1724 Antonio Palomino publishes the first biography of Velázquez.

1734 The royal palace in Madrid is destroyed by fire; many works by Velázquez are destroyed or badly damaged in the blaze.

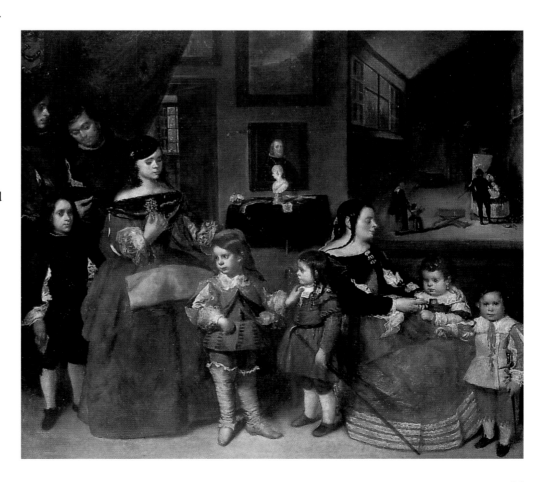

Photo credits